woman as goddess

Liberated Nudes by Robert Markle and Joyce Wieland

Anna Hudson
with essays by Brenda Lafleur and Peter Unwin

ART GALLERY OF ONTARIO TORONTO

Printed and bound in Canada
National Library of Canada Cataloguing in Publication

Markle, Robert, 1936–1990
Woman as Goddess : Liberated Nudes by Robert Markle and Joyce Wieland / Anna Hudson ;
with essays by Brenda Lafleur and Peter Unwin.

Catalogue of an exhibition held at the Art Gallery of Ontario Nov. 29, 2003–Feb. 29, 2004.
ISBN 1-894243-36-6

1. Markle, Robert, 1936–1990—Exhibitions. 2. Wieland, Joyce, 1930–1998—Exhibitions.
3. Nude in art—Exhibitions. I. Wieland, Joyce, 1930–1998. II. Lafleur, Brenda III. Unwin, Peter, 1956–
IV. Art Gallery of Ontario. V. Title.

ND249.M355A4 2003 704.9'421'0971074713541 C2003-905761-5

The Art Gallery of Ontario is funded by the Ontario Ministry of Culture. Additional operating support is received from the Volunteers of the AGO, City of Toronto, the Department of Canadian Heritage, and the Canada Council for the Arts.

Supported by The Canada Council for the Arts through the Assistance to Art Museums and Public Galleries program.

Cover:
52.
Joyce Wieland
Untitled (lovers joined), between 1954 and 1958
Ink on paper
21.5 x 28.0 cm
Art Gallery of Ontario, gift of Betty Ramsaur Ferguson, Puslinch, Ontario, 1998

39.
Robert Markle
Hanover Hustle, 1988
Acrylic and pastel on paper
Diptych, left panel: 120.2 x 149.2 cm; right panel: 120.6 x 149.4 cm
Art Gallery of Ontario, gift of Marlene Markle, Holstein, Ontario, 2001

Graphic Design: Aleksandra Grzywaczewska, AGO
Photography: Carlo Catenazzi, AGO
Printing: Bowne of Toronto
Typography: Univers and Fruitopia

Art Gallery of Ontario

contents

Preface

Woman as Goddess: Liberated Nudes by Robert Markle and Joyce Wieland is the first in a proposed series of exhibitions to be organized through the Art Gallery of Ontario's Canadian Art department that will explore in provocative and, we trust, thoughtful ways the contributions of key figures of that generation of artists who emerged during the first two decades of the second half of the twentieth century. Those who knew Markle and Wieland will be surprised by our bringing them together in this way, for in their time they appeared antipathetic to one another, virtually incompatible personalities who certainly seemed squarely positioned on opposing sides of the sexual struggles that characterized their era. *Woman as Goddess*, however, reveals them to have been essentially on two sides of the same coin, joined in similar investigations of the fecund symbolism of the female body and remarkably closely aligned in how each linked the female figure to his or her particular sense of place and, ultimately, personal identity.

Anna Hudson, Associate Curator, Canadian Art, is to be congratulated for first imagining, and then realizing, this enormously rich exhibition. She and her co-authors of this catalogue, Peter Unwin and Brenda Lafleur, similarly are to be lauded for so effectively engaging the exhibition's manifold implications. Marlene Markle, the artist's widow and his favourite model, has been essential to the success of this project, as has been Doug MacPherson, executor of the Joyce Wieland estate. Andy Wainwright gave much good advice concerning Markle, and two close friends of Wieland, and now keepers of the flame, Betty Ferguson and Sara Bowser Barney, were essential guides into that special world. Thanks are also due to Avrom Isaacs for his assistance. Finally, Waddington's Auctioneers must be thanked and praised for so generously supporting this venture into new territory in Canadian art history.

DENNIS REID
Chief Curator

Sponsor's Foreword

To have aroused emotions with your art – what an exquisite legacy!

Robert Markle and Joyce Wieland, two extraordinary Canadian artists, explored and presented the female form in their individual and unique ways, arousing Canadian sensibilities and provoking the establishment to consider new artistic boundaries.

Waddington's is honoured to sponsor *Woman as Goddess: Liberated Nudes by Robert Markle and Joyce Wieland*. In our profession we are privileged to work with some of the best art created in Canada, as well as from around the world. We are particularly touched by art that moves us – art that makes us both think and feel. This is the art of Robert Markle and Joyce Wieland.

Markle and Wieland were Toronto artists, both of the working class, both obsessed with creating their art. Although different in their interpretations of the female nude, Wieland and Markle shared the same times, the radical 1960s, and the same coterie of artists who made up the Isaacs gang, creating art, drinking beer and revelling in jazz. Wieland still represents the ideal role model and mentor, with her free spirit and powerful feminist view on the role of the new sensual woman. Her art is personal; the figures she created were often drawn from her own self-image, the kitchen and bedroom her inspiration. Robert Markle's view of women was somewhat different; he often treated female students at the New School of Art with disdain, but wrote, "All women, remind me of what beauty is." Markle's figures explode, gyrate, and strut blatant sensuality from their burlesque pedestals. Differing in their interpretations but synchronous in their passion, the art of Robert Markle and Joyce Wieland comes together in this exhibition to both contrast and complement, nurture and arouse in the unique paradox that is Canadian art.

As sponsor for this exhibition, Waddington's congratulates the Art Gallery of Ontario, exhibition curator Anna Hudson and the AGO staff for offering us the opportunity to once again be moved by this extraordinary Canadian art.

DUNCAN MCLEAN
President
Waddington's Auctioneers

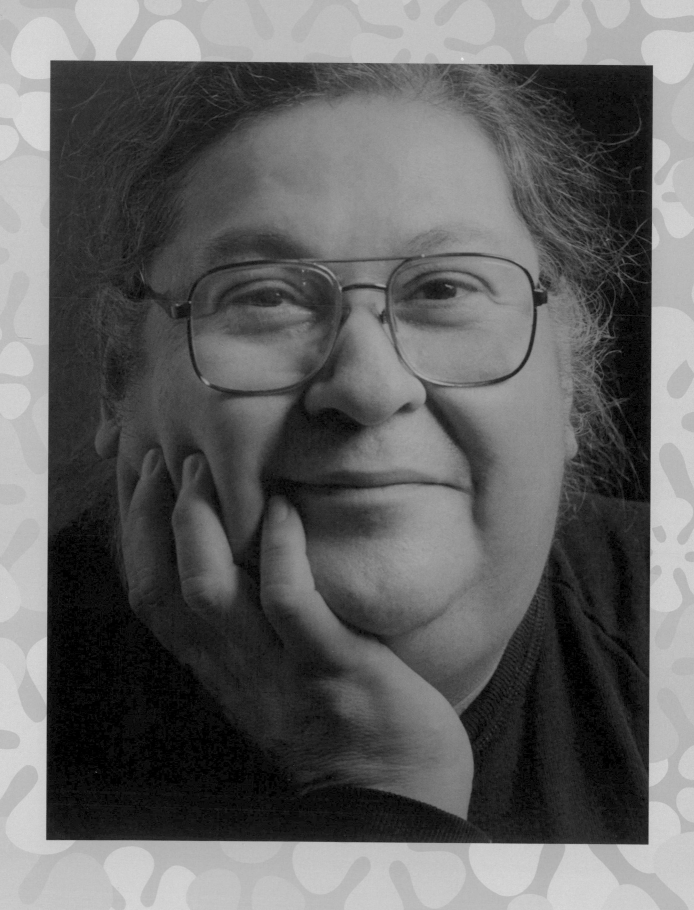

getting a stone
aroused

An Attempt at Robert Markle

By Peter Unwin

On a summer afternoon in the early 1960s, Toronto police officers burst into the top floor of a Yonge Street studio, looking to apprehend the robber of a Yonge Street bank. Instead they found Robert Markle, wearing large glasses and surrounded by paintings and sketches of nude women. The officers, according to Markle's notebooks, poked about until one of them discovered a pair of binoculars which he took to the window and aimed at the bank.

"Jesus Christ," he yelled "I can see the goddamn serial numbers on the vault from here!" Markle, who had been using the binoculars to peep at the mini–skirted legs of the tellers below, answered calmly,

"I'm an artist. I turn the binoculars backward to get a different perspective on my work."

Unsure what to make of this, the police left, but not before one of them turned and waved a finger in Markle's face.

"Smarten up!" he warned.

But it was too late for that.

Robert Markle was born in Hamilton, Ontario, in 1936. His father was a "Mohawk in high steel"; the phrase has become common after Joseph Mitchell's 1949 *New Yorker* article and refers to the most glamorous and dangerous job in the construction industry. "Men who want to do it are rare," wrote Mitchell. "Men who *can* do it are rarer." It was agreed this job was best done by Mohawks who apparently "did not have any fear of heights."

Fearful or not the work was dangerous. A 1907 accident on the Quebec Bridge killed 97 men – 35 of them were Mohawks. This danger, combined with long absences from home, defined the working life of men in high steel, including Markle's father, Bruce, who perished in a Buffalo hotel fire while away on a job.

Robert Markle was then nine years old and living in a small house on Barton Street in Hamilton's east end. Directly across the street was Mahoney Park where the Mahoney Bears played baseball, and where Markle and his sisters skated on winter mornings. Before them a vast industrial landscape stretched to the lake.

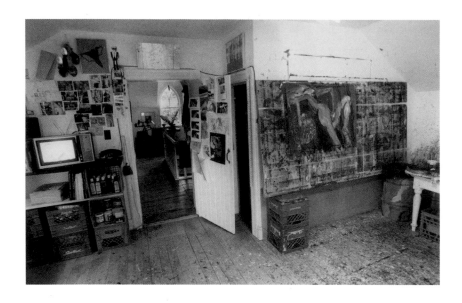

Here in this small house on Barton Street began the fascination with the female that would soon come to define Markle's entire artistic output. In a delightful Christmas memoir that appeared in *Toronto Life*, December 1977, he wrote of this time, "My life was being transformed by my mother's unerring understanding of love."

To Markle even Christmas was female. The morning was called into existence by his sister, who woke him up, then the visuals of his mother's living room, "the reds, greens, ribbon-golds, purples, soft blues, yellow, half-hidden in amber shadow, dusky under a blazing tree." Finally, the gifts. Giving out presents, observed Markle, "was woman's work."

Later his family sat down at a dinner table covered in lace, the tatted and intricate expression of a woman's quiet labour. This lace, Markle noted, was older than himself. Here, in the heart of his mother's home, he received his most meaningful training as an artist. "At my mother's Christmas table," he wrote, "I learned ritual and excellence."

In 1954 the eighteen-year-old left home for Toronto to become in his words, "a big time painter." This opportunity, like many in his life, was precipitated by the generosity of women; this time a scholarship from the Imperial Order Daughters of the Empire.

Robert Markle's dramatic failure as an art student has come to form the core of a minor legend. Chafing under the strictures of the Ontario College of Art, the frustrated twenty-year-old hurled a bottle of acid against a wall and was promptly expelled. His girlfriend, fellow student, and soon-to-be his wife and life-long model, Marlene Shuster, left with him, informing the dean that if he was going to expel Markle, he'd better expel her as well.

What the legend leaves out is a devastated twenty-year-old student writing home to his mother to explain he has been kicked out of art school. In her response his mother, Kathleen, gently laments Robert's failure to control his emotions, and suggests reasonably that the school had no choice but to expel him. She adds, "I will also be on your side no matter what. You will *never be a failure!*" Her faith was rewarded. In less than ten years her son would become, at least briefly, one of the most discussed and written-about painters in the country.

Fig. 3
John Reeves
Canadian, born 1938
Robert Markle's studio,
Holstein, Ontario, 1990
Black and white RC print
© 2003 John Reeves

For a great deal of the twentieth century the female figure in Canadian painting has existed almost fully clothed beneath the dominance of landscape art and a somewhat puritanical fear of human flesh. In 1931 the Art Gallery of Toronto found it prudent to remove juried works of naked figures from its walls. The Montreal Museum of Fine Arts did the same a decade later. Artist William Brymner wondered "Why the human body is in such disgrace among us?" and Joseph Russell, after twenty years in Paris, returned to Canada and exhibited nudes which, according to art historian Jerrold Morris, were received with "vociferous horror." Artist LeMoine FitzGerald hung a nude over his mantelpiece but took it down after a neighbour complained that her son could see it through the window. The near official dominance of landscape art was confirmed in 1967 when the National Gallery of Canada mounted its 300 year retrospective of Canadian art and went so far as to include *one* nude.

Into this frosty environment strode a young Mohawk determined to turn his talents toward the female figure. Having recently been ousted from the guiding influence of art school and, more importantly, its life drawing classes, Markle sought his subject where he could – in the burlesque halls of Yonge Street and Spadina Avenue.

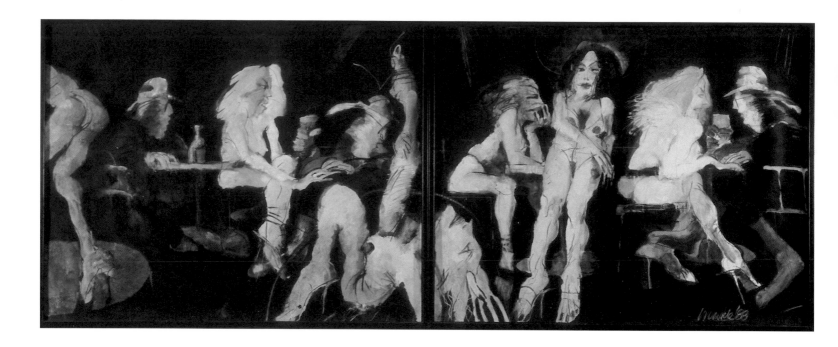

39.
Robert Markle
Hanover Hustle, 1988
Acrylic and pastel on paper
Diptych, left panel: 120.2 x
149.2 cm; right panel: 120.6 x
149.4 cm
Art Gallery of Ontario,
gift of Marlene Markle,
Holstein, Ontario, 2001

In these smoky rooms the female body was seen in its power. Here the body was full of movement and agency; "heroic," Markle called it; erotic and alive. This stands in sharp contrast to the artist's studio model, who is professionally submissive, demure, and whose poses are not her own.

Through the stripper Markle tackled what is arguably Western art's most storied and esteemed subject, expanding the parameters of the Nude to include the nudie, the girly picture, the cheesecake, show girls, the net stocking, the stiletto heel, and the ostrich feather boa.

Markle was soon light years removed from the east end of Hamilton. He lived in the heart of Toronto, inhaling the intoxicating scene taking place in the few blocks around Yonge and Bloor: The Purple Onion, the Mynah Bird with its stark naked chef, topless dancers, Go–Go girls in cages, the Riverboat, the performances there by a young man named Gordon Lightfoot, soon to become Markle's friend and drinking companion; The Isaacs Gallery, Rochdale, free love....

"I was already an arrogant self-centred prick," wrote Markle. "But in spite of that I knew I had a lot to learn." That learning involved a reading of Marshall McLuhan

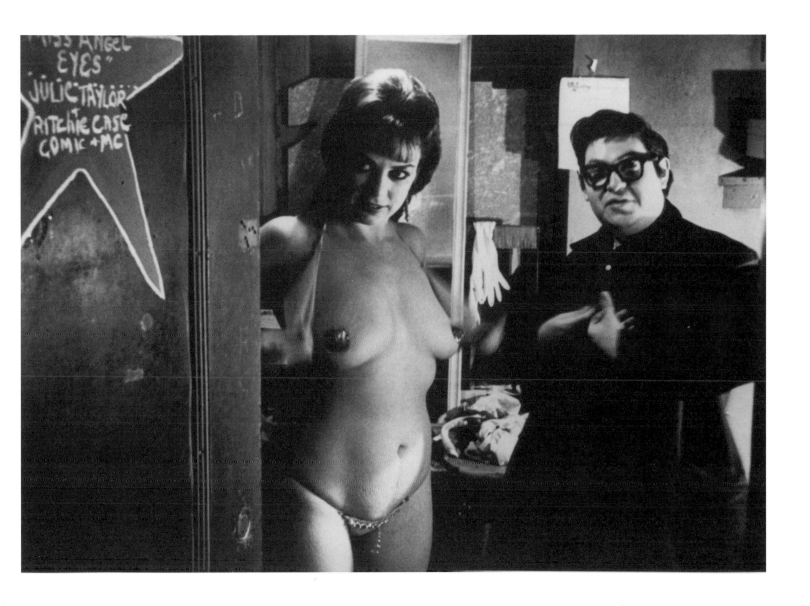

from whom Markle took the following note: "Open mesh silk stocking is far more sensuous than the smooth nylon, because the eye must act as a hand, filling in and completing the mirage."

In 1965, in a famous raid, the morality police (the "Hogtown Squad" as Vancouver reporters gleefully called them) removed Markle's drawings from the Dorothy Cameron Gallery, ensuring Markle's celebrity, and bankrupting one of Canada's most vibrant outlets for contemporary art. A radio reporter informed Markle that a judge had ruled that his picture *Lovers No. 1* depicted lesbian activity, which was not allowed. A seething Markle answered, "Yeah?"

Markle was approaching the status of icon. He was a member of the Isaacs All-Stars, of the Artists' Jazz Band. He would lend his name to a restaurant called,

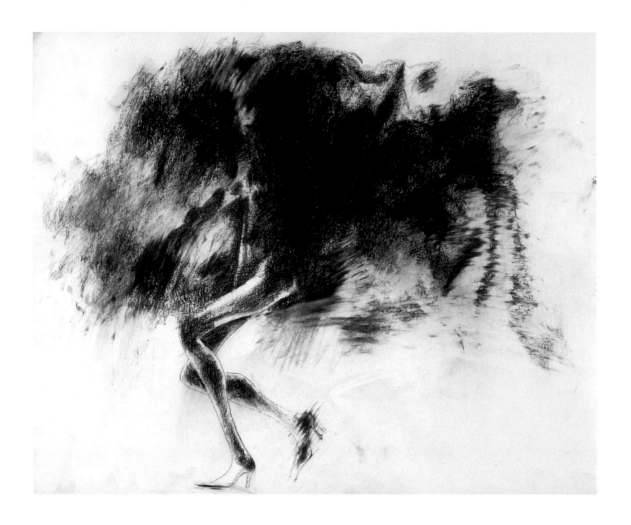

of course, *Markleangelo's*, and be a founding member of Arts' Sake Inc. He, along with other artists, began teaching at the New School of Art, the antithesis of the Ontario College of Art – all courses taught by "practising artists."

As a teacher Markle invited his students to look hard at their own drawings and "try to figure out why they're all so shitty." Afternoon classes were conducted in the Brunswick Tavern. Here, according to artist Vera Frenkel, "the conversation was always interesting and sometimes even about art." Also here, in the defining sexism of the Toronto art scene of the 1960s and 70s, the young Vera Frenkel, following one of Markle's pompous, if not insufferable rants, poured a pitcher of beer over his head and earned his undying respect.

Markle was coming into his own at a time when feminism was called *Women's Lib* and a feminist a *Woman's Libber*. Despite his lifelong and relentless pursuit of the female nude, he has largely escaped the approbation of feminist criticism and even scrutiny. "What is a feminist to do with Robert Markle?" asked Marjorie Stone at a 1991 Markle retrospective. While observing that Markle's "celebration of female sexuality" usually occurs "somewhere on the border between the erotic and the

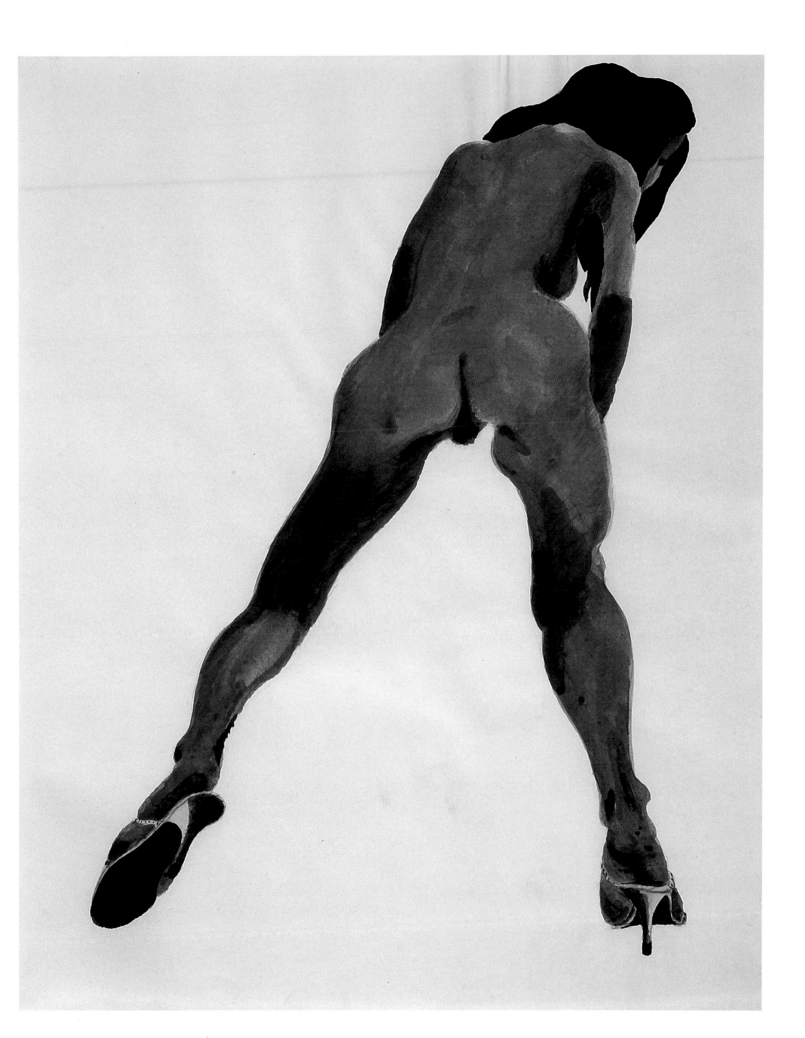

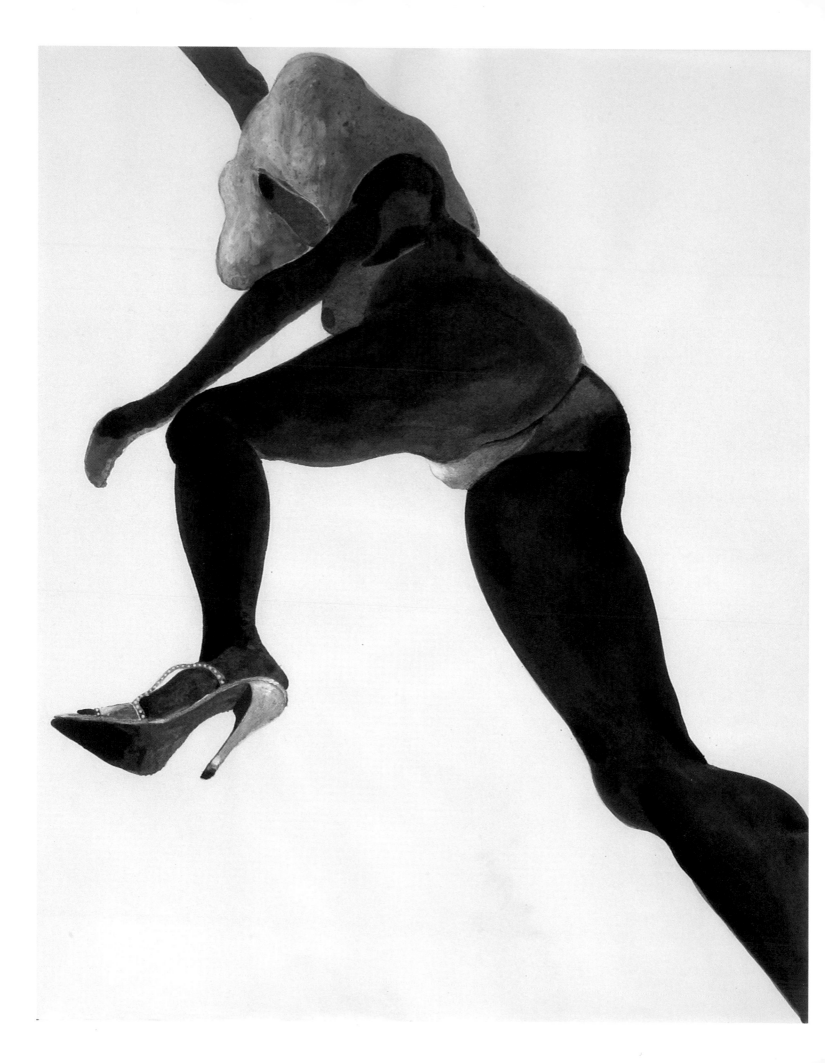

grotesque," she answers her own question by suggesting that the viewer "participate in the dialogue or polylogue about gender that viewing his work provokes."

The advice is sound, although it is quite possible Markle would have dismissed it as "another dreary stab at getting one's mental rocks off" – a phrase found in his writings. Despite this predictable pose of anti-intellectualism, Markle was arguably as scholarly, bookish and as well-educated as any Canadian artist before him or since. It is impossible to be any more intellectual (or succinct) than Markle himself when he addresses in his notebooks the central issue of his own creative process:

> The thing I have most difficulty in dealing with is that distance between outright arousal and the true aspect of perception. I always believe that appeasement of the picture comes before appeasement of myself, but how to explain that seems beyond me. Maybe for the best.

When Markle impersonates Rembrandt on the Global television show *Witness To Yesterday*, the learning, the confidence and the arrogance oozes from him. He is utterly convincing as Rembrandt – uncomfortably so, as if Rembrandt was some minor artist attempting to imitate – *him*. Markle arrived at the taping with a hangover, was offered coffee but demanded speed instead, which the studio staff graciously provided. At one point the frustrated host, Patrick Watson, poses a somewhat windy question to which either Markle or Rembrandt (it is difficult to tell) snaps back, "What are you asking me? Was I a happy man?" Clearly the artist cannot imagine a more contemptible question.

Fortunately these various posturings on the part of Robert Markle do not conceal the work itself, the determined representation of the female form that invokes de Kooning and Matisse, nature and jazz; the flowing, unexpected lines that sound the work of Thelonious Monk, Miles Davis, and Markle's favourite, Lester Young.

Strippers, wrote Markle, especially the good ones, "reach out through the eyes of the audience to get a better look at themselves." This intriguing observation indicates how deeply he had thought through his artistic project. The link between the viewer and the viewed, the stripper and the customer, is kinetic and fruitful. It is strikingly similar to the patron in an art gallery – reaching out through the eyes of the artist to get a better look at her – or himself.

For Markle this better look demanded sexuality, nakedness, flesh, skin and passion. He wrote: "There is a grace in lust that touches on a type of controlled panic."

23.
Robert Markle
Untitled, between 1970 and 1975
Coloured inks on paper
Sketchbook 3
Robert Markle fonds, series 12, box 19,
E.P. Taylor Research Library and Archives,
Art Gallery of Ontario

This is where his art exists. Strangely, at the very point where arousal should happen, it usually doesn't. The image refuses to slip into the reassuring safety of pornography; it bolts instead into the unfixable and more dangerous terrain of art. Even Markle's bondage sketches (he called them more accurately "held figures") refuse to deliver the titillation presumed to take place when the unbound and dressed viewer gazes upon the powerless and naked subject. Even in bondage his nudes cannot be held back, they exist strong and unrestrainable. Instead it is the gear of bondage that appears stilted, inorganic and poorly rendered; the ropes, the straps, the trappings have no chance against these figures and the power that exudes from them.

In a videotape, *Priceville Prints*, Markle can be seen painting the breasts of one of his figures. "Exploding tits," he exclaims happily. This coarse and kinetic tendency toward erupting flesh is not unusual in the Markle canon. Strippers, he wrote, "with bombastic bellies," and "women falling, all legs arms, soft flesh, falling through my eyes, my time, falling through my life, sucking my air, touching my mind." For all of this imagery, with its rock-lyric modernity, Markle's nudes also owe a great deal to the muse of nature. They are formed of the landscape, sometimes to such an extent that it's difficult to differentiate between the trunk of a woman and the trunk of a tree. There are paintings in which the branches of a tree are no different from a woman's arms or legs. Both are crooked and alive, both filled with water and living fluid. He paints the bays and inlets of a woman's body, the flowing river bank of the calf and thigh. He immerses her in water which, on second look, could easily be stage light.

For all of his contemporary indifference toward landscape, Markle's painted nudes are often indistinguishable from the earth, just as the earth is indistinguishable from the nude. In his writing he drives the same point home; "the spun eyes of water... the softly found summer bronzed flesh... breasts of polished stone... winter's white bikini...." In a collage he cuts out the image of a river and turns it into a winding tongue that ends up flowing from a human face. There are times when the nude becomes a branch, a brown stick figure; times when flesh becomes the colour of bark and dirt, and the appendages turn into paws. Calves will suddenly bulge outward, like trees thickening at that point where they touch the ground.

Typically the Markle nude is elevated by the shoe, the ubiquitous stiletto. The high heel for Markle is the pedestal on which he mounts his inquiry. High heels become a signature, evolving over the years as he himself evolves as an artist. These immense and spindly shoes are the artificial devices that keep her from touching the ground, yet the feet of Markle's nudes are massive and powerful, the shoes have no chance

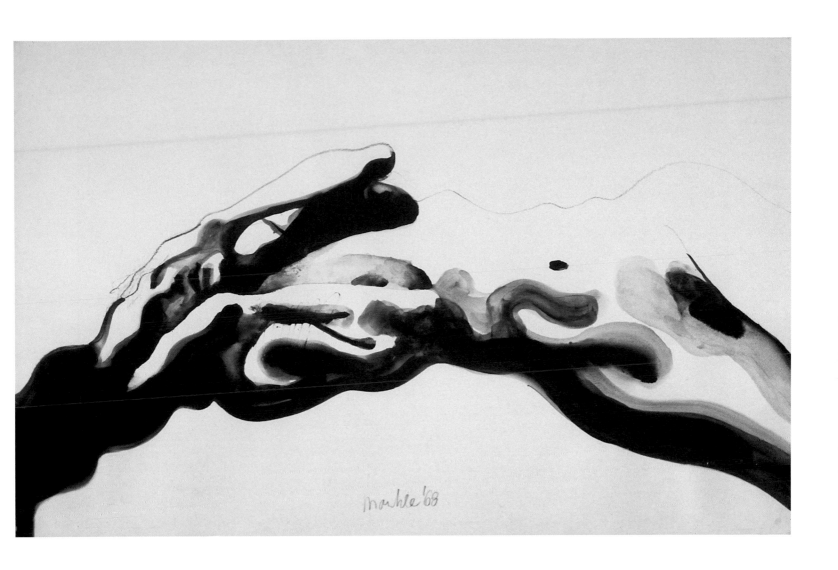

against her. Like the ropes in his bondage sketches, they fail every time. The spiked heels, for all the loving and fetishistic attention they receive, are incapable of disempowering the women who wear them.

 "All women," wrote Markle, "remind me of what beauty is." This is the democratic core of his vision and permeates Markle's output, both literary and visual. All women, he insists, (even "the perfumed Rosedale lady lusting") "are the most beautiful women in the world." Markle did not have hangovers, he had "black lace hangovers." In an article on buying a stereo, he recommends the Sure Type 3 diamond needle, because it "caresses and fondles" your records. When he was in his studio working, he was, in his words, painting his wife, recovering and reloving and redrawing her. In *Priceville Prints*, a confident Harold Klunder blithely says to Markle that his (Klunder's) painting would be no different if he was a woman.

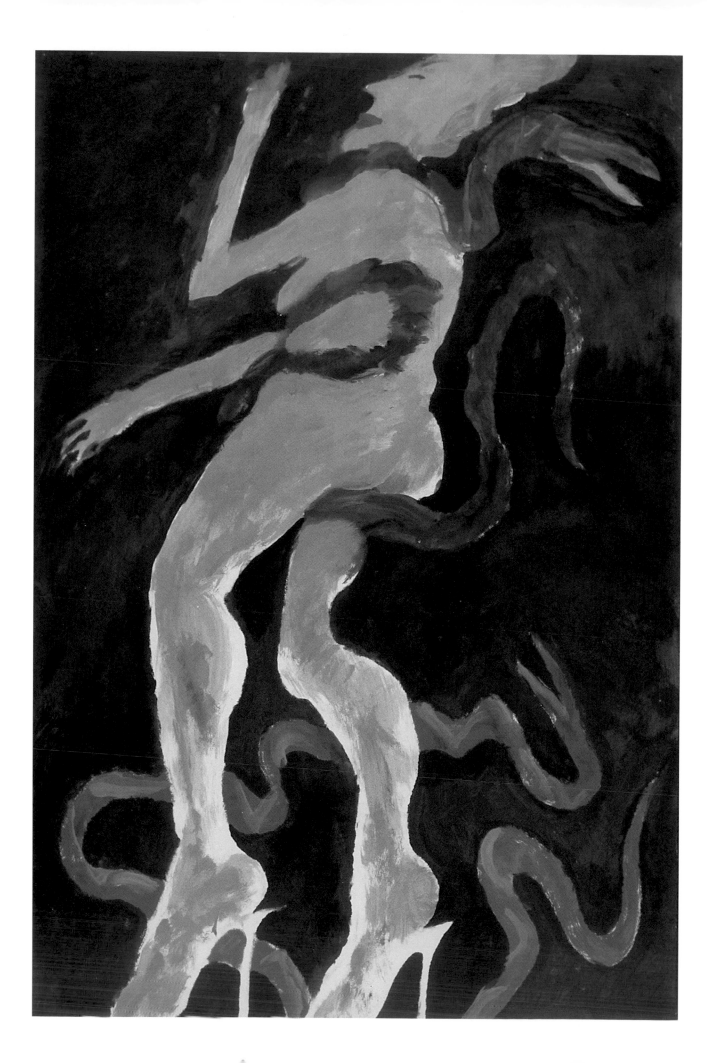

"You don't know that," interjects Markle at once, almost angrily. "You don't know about *the woman part of it!*" Not knowing the woman part of it, that mystery, is the drive behind a great deal of Markle's art. Inherent in the mystery is the dance and the power of human flesh. "As I am aroused," he wrote, "so must they be aroused." Markle was himself fully aware of the moral Puritanism that drives the War on Pornography. He saw it first hand when police officers removed his black and white female nudes from the walls of the Dorothy Cameron Gallery. He saw it in the moral hysteria that followed the murder of Emmanuel Jacques, a Yonge Street shoeshine boy. "The purge is on," he wrote. "The purge is ugly." The antidote to the purge is a celebration of the erotic, of the naked, human flesh, of undulating kinetic strippers who Markle called "heroines" and "giants." And to whom his gratitude is palpable.

In *Priceville Prints* there is an image of Markle, a bolt of grey hair tied behind the back of his head, jowls that overflow his face, large dark-rimmed glasses and the ubiquitous stained and battered Red Man Chewing Tobacco cap. He is seated at the back of the studio directing an electric hair dryer at a lithographic stone. Through the roar he shouts, "I'm just trying to get this stone aroused."

A better summation of Markle is hard to imagine.

As a young man Robert Markle penetrated the most privileged, the most influential and the most elite art scene in Canada. He did so as a "Native," what he called an "Indian," a Mohawk Indian – the most influential and storied member of the Six Nations Confederacy, a confederacy about which another Mohawk artist, Pauline Johnson, said that no other government existed.

He was born not Markle, but *Maracle*, a name found throughout the latter centuries of Six Nations history and today, throughout the phone books of southern Ontario. It is suggested that Robert Maracle become Robert Markle at the insistence of his mother, who must have known the burden of Indianhood and was attempting to protect her children from shouldering it, at least in name. In a 1977 letter regarding his Indian status, Robert Markle discovered he was registered as an "Indian" under Band No. 1358, "Band Name: Mohawks of the Bay of Quinte." Not surprisingly, he made this inquiry into his Native status to find out if he qualified for an off-reserve housing grant.

In today's culture of almost obligatory "identity politics," it is startling to see just how little interest Markle had in exploring or exploiting his Native heritage. There were only three things, insisted Markle, that he never thought about, "being an Indian, fame, and art." Whether he thought about his Native background or not,

38.
Robert Markle
Snakes Galore, 1988
Acrylic on paper
111.8 x 76.0 cm
Art Gallery of Ontario,
gift of Marlene Markle,
Holstein, Ontario, 2001

the body in trouble

These are troubled bodies. These are bodies in trouble and making trouble.

by Brenda Lafleur

Joyce Wieland is to blame for all this. She is the troublemaker. Wieland paints, draws, quilts, embroiders, casts, and films bodies that get into trouble. But what kind of troubles are these bodies in? Are they the kind of bodies Hélène Cixous describes, bodies that are "guilty of everything, guilty at every turn: for having desires, for not having any; for being frigid, for being 'too hot'; for not being both at once; for being too motherly and not enough; for having children and for not having any...."?[1]

It is a circular movement between making trouble and being in trouble. As Judith Butler notes, "the rebellion and its reprimand seem to be caught up in the same terms.... The prevailing law threatened one with trouble, even put one in trouble, all to keep one out of trouble."[2] These bodies get into trouble because they push against the repertoire of images through which Western culture imagines the female body and female identity is inscribed. Look at the bodies in *Menstrual Dance* (cat. no. 104, p. 76), *Untitled (bather and hare)* (cat. no. 93, p. 77) and *Facing North-Self Impression* (cat. no. 87, p. 77). They are, echoing Mary Russo, the "open, protruding, extended, secreting body, the body of becoming, process and change."[3] These are the kind of bodies my mother warned me about – the ones that do not respect borders or rules.

In *Clothes of Love* (cat. no. 77, p. 67) the red-stained cloth hanging on the line becomes a fulcrum upon which the metaphorical body teeters between pleasure and loss. The red markings – associated with blood, wounds, passion, sex, violence, death – in *Clothes of Love* and *Redgasm* (cat. no. 75, p. 78) evoke both danger and desire. They are the kind of bodies Russo describes as making a "spectacle" of themselves:

> Making a spectacle out of oneself seemed a specifically feminine danger.
> The danger was of an exposure.... For a woman, making a spectacle out of
> herself had more to do with a kind of inadvertency and loss of boundaries:
> the possessors of large, aging, and dimpled thighs displayed at the public
> beach, of overly rouged cheeks, of a voice shrill in laughter, or of a sliding
> bra strap – a loose, dingy bra strap especially – were at once caught out by
> fate and blameworthy. It was my impression that these women had done
> something wrong, had stepped, as it were, into the limelight out of turn –
> too young or too old, too early or too late – and yet anyone, any *woman*,
> could make a spectacle out of herself if she was not careful.[4]

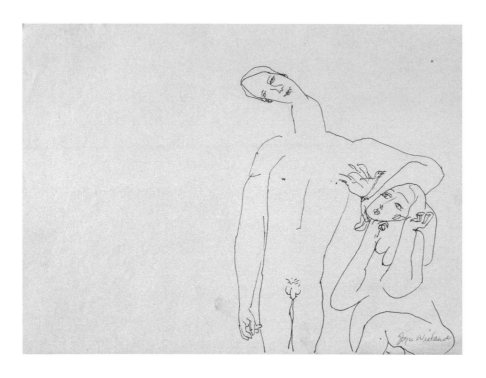

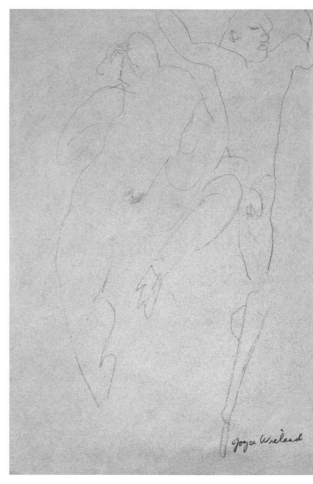

And what of the bodies in *Victory of Venus* (cat. no. 95, p. 78), *Untitled (lovers with dove)* (cat. no. 51, above), and *Untitled (lovers jumping)*(cat. no. 73, above)? They fly, fall, dance, battle, swoop, crouch, make love, turn away from, turn toward and struggle. These are not the languid, static and sleek women of classical art, the bodies of Titian (*Venus of Urbino* [fig. 6]), or Ingres (*Large Odalisque* [fig. 7]).

Wieland's images both emerge from and rewrite art history's fascination with the female body. In two witty cartoons from the 1960s, Wieland takes a poke at the art establishment's obsession with the female nude. In one, *The new 'Old Master' machine – perfected and demonstrated January 19, 1964* (fig. 8), a male artist stands on a chair before an audience controlling a machine that mechanically churns out a painting of a woman. The paint flows from tubes labelled *hair, lace,* and *space*. In *Special today, inflate kit, blow up a picture* (fig. 9), a man purchases a box of inflatable art. As he pumps air into the object, an inflatable picture frame is formed and then is filled in by an inflatable nude woman with her arms in a stereotypical girlie pose. These two cartoons humorously ask us to consider how art has dealt with themes of women's bodies.

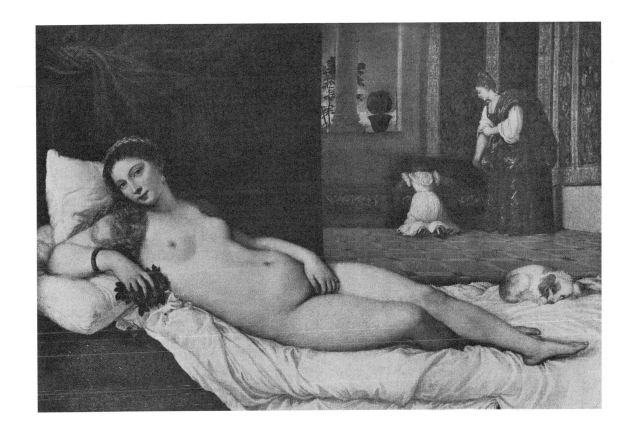

Fig. 6
Titian
Italian, c. 1485–1576
Venus of Urbino, 1538
Oil on canvas
119.0 x 165.0 cm
Uffizi Gallery, Florence

Fig. 7
Jean-Auguste-Dominique
Ingres
French, 1780–1867
Large Odalisque, 1814
Oil on canvas
162.0 x 91.0 cm
Louvre, Paris

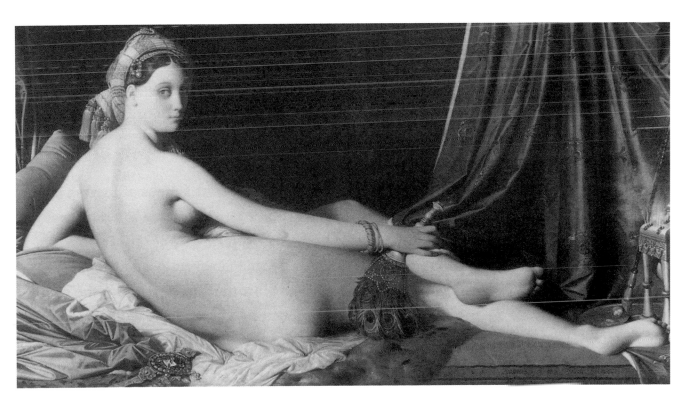

Even the way Wieland draws the bodies highlights the sense of "process," of the always-becoming. There are lines that do not always connect up, there are gaps and openings, a disparity between desire and result. It is the metaphorical porousness of these bodies to multiple and sometimes contradictory meanings that give these works such currency today.

When I began my research for this essay, I was uncomfortable with many of the claims about Wieland and her work. Yet I was also aware of the trouble that can be caused by moving away from a "real" politics towards a "theoretical" one. The challenge, as Jacqueline Rose has identified it, is how to articulate a point of resistance or defence without filling it up with visions of psychic and/or social utopia.[22]

Many groups have claimed Wieland as their own. She has been held up as an example of how "great" women artists have been left out of the canon – in particular, the histories of experimental film and avant-garde art. Yet, as Linda Nochlin has insightfully shown, this tactic often ends up reinforcing the terms (art, artist, greatness) that led to the exclusion in the first place.[23]

Another strategy has been to set up Wieland's art as exemplifying a different kind of "greatness" – one that stems from her "female viewpoint" rooted in the body, which is distinct from what men have to say. Yet surely we want to steer clear of this minefield. Most feminists now believe that essentialist discussions of "woman's perspective" or "female sensibility" are built on uncritical assumptions about the category of "woman." These assumptions are usually based on white, middle-class, heterosexual normativity that excludes those outside of the "official" body. Most contemporary feminisms no longer consider "woman" a category that is stable and self-evident.

Wieland's art also has been described as autobiographical in aesthetic and practice. Although biographical materials can provide necessary information for people(s) excluded from "official" history, there is a danger in making works speak for their authors and authors speak for their works. Pollock warns against the pitfalls of modernist notions of artistic intentionality:

65.
Joyce Wieland
Picture Upset by the Moon,
between 1956 and 1958
Ink on paper
13.6 x 20.4 cm
Art Gallery of Ontario, gift
of Betty Ramsaur Ferguson,
Puslinch, Ontario, 1998

But surely there is a difference between careful interrogation of the elements of the archive, which include materials on a lived life, and the binding back of paintings onto the life unproblematically there for us to know, such that the paintings become the direct deposit of a life experience and our vicarious access to how it felt to live that life.[24]

Wieland's images have been interpreted as reflections of a time period, as representations of the female voice in a male-female opposition, or as an artistic autobiography of Joyce Wieland herself. But none of these views does her work justice, nor are they ultimately helpful to someone trying to engage with Wieland's work today. Instead, these views lock her work in a construct from which they cannot escape. To appreciate Wieland's work fully, we must take Walter Benjamin's warning seriously: that "every image of the past that is not recognized by the present as one of its own concerns threatens to disappear irretrievably."[25]

To make Wieland's bodies "one of our own concerns," they must be re-opened, re-visited, re-vised, re-thought, and re-considered – the *re* pointing to a multiplication of the original meaning. It marks the desire (mine) to reconfigure and reinscribe Wieland's works and how we think about them.

I suggest that Wieland's troubled and troubling bodies make it possible, despite the angry age we live in, for us to "light up" what is usually rejected in disgust and rage. By doing this, they help us, using Silverman's phrase, to "see differently."[26]

Endnotes

1 Hélène Cixous, "The Laugh of the Medusa," in *New French Feminisms*, eds. Elaine Marks and Isabelle de Courtivron (Brighton: Harvester, 1981), 250.

2 Judith Butler, *Gender Trouble: Feminism and the Subversion of Identity* (New York and London: Routledge, 1990), ix.

3 Mary Russo, "Female Grotesques: Carnival and Theory," in *Feminist Studies/Critical Studies*, ed. Teresa de Lauretis (Bloomington: Indiana University Press, 1986), 219.

4 Russo, "Female Grotesques," 213.

5 Griselda Pollock, review of *Artemisia Gentileschi: The Image of the Hero in Italian Baroque Art*, by Mary Garrard, *The Art Bulletin* 72 (September 1990): 500.

6 Georges Balandier, *Political Anthropology* (London: Allen Lane, 1970), quoted in Peter Stallybrass and Allon White, *The Politics and Poetics of Transgression* (Ithaca: Cornell University Press, 1986), 14.

7 Kaja Silverman, *The Threshold of the Visible World* (New York and London: Routledge, 1996), 3.

8 Silverman, *Threshold of the Visible World*.

9 Ibid., 3.

10 Ibid., 4.

11 Ibid., 4.

12 John Berger, *Ways of Seeing* (London: Penguin, 1972), 51.

13 Paul Schilder, *The Image and Appearance of the Human Body: Studies in the Constructive Energies of the Psyche* (New York: International Universities Press, 1950), 11, quoted in Silverman, *Threshold of the Visible World*, 13.

14 Jacques Lacan, "Some Reflections on the Ego," *International Journal of Psychoanalysis* 34 (1953), 13, quoted in Silverman, *Threshold of the Visible World*, 20.

15 Judith Butler, *Bodies That Matter: On the Discursive Limits of "Sex"* (New York and London: Routledge, 1993), 114.

16 Joyce Wieland. Quoted in Marie Fleming, "Joyce Wieland: A Perspective," *Joyce Wieland* (Toronto: Art Gallery of Ontario, 1987), 108.

17 Silverman, *Threshold of the Visible World*, 27.

18 Butler, *Bodies That Matter*, 105.

19 Judith Butler, *Subjects of Desire: Hegelian Reflections in Twentieth-Century France* (New York: Columbia University Press, 1987), 21.

20 Ibid., 22.

21 Jan Allen, *Twilit Record of Romantic Love* (Kingston: Agnes Etherington Art Centre, c. 1995), 7.

22 Jacqueline Rose, "Feminism and the Psyche," chap. in *Sexuality in the Field of Vision* (London: Verso, 1986), 8.

23 Linda Nochlin, "Why Have There Been No Great Women Artists," in *Women, Art and Power and Other Essays* (New York: Harper & Row, 1988), 164–178.

24 Pollock, review of *Artemisia Gentileschi*, 502.

25 Walter Benjamin, "Thesis on the Philosophy of History," *Illuminations*, ed. Hannah Arendt, translated by Harry Zohn (New York: Schocken, 1968), 255; quoted in Mieke Bal, *Travelling Concepts in the Humanities: A Rough Guide* (Toronto: University of Toronto Press, 2002), 62.

26 Silverman, *Threshold of the Visible World*, 227.

15.
Robert Markle
Paramour, 1965
Charcoal and tempera
on paper
89.1 x 58.4 cm
Art Gallery of Ontario,
purchased with funds
donated by AGO Members,
2001

as a symbol of Art. She was compelled to measure herself as an artist and as a woman against Art's feminine forms. Both Markle and Wieland were drawn into an exploration of her place, of Art in contemporary society.

The archetypal "Marklechick," a dark-haired long-legged nude, gyrates any way the wind blows in *Creation* (cat. no. 35, p. 65) a folk art whirligig of 1988. Markle's unmistakable profile looms large at her feet, poised ready to paint with palette in hand. She focuses hard on the artist's penis-as-paintbrush. Four Markle profiles spin behind her head to the ecstatic rhythm of her hips. "Art-making itself," so it seemed to feminist art historians of the seventies, "is analogous to the sexual domination of whores."[2] Even worse, the modern artist's exhortation of his model was perhaps more than a mere reflection of the male psyche. "[T]he nude, as a genre, is one of the many cultural phenomena that teaches women to see themselves through male eyes and in terms of dominating male interest."[3] Wow, Wieland would just explode... and not in that wonderful way Markle talked about when he instructed students at Toronto's anti-establishment New School of Art, later known as Arts' Sake Inc. "Big on the page, I kept shouting at them,... I want that figure to explode, in your mind, and on the page!" "And in those days," remembered Markle, "figures did explode, a lot of lush flesh fell between the cracks of carnality and creativity." Outside of the studio, in the rush of city life, the clinical nude became a woman of infinite mystery, "she became art masked by the muse, pure desire, the artist model."[4]

Art and sex were intimately woven through Markle's painted, drawn, sewn, and sawed artist's models through thirty years of work. He worshipped her as creativity *in potentia*, the addictive opiate of aesthetic experience so difficult to put into words. He found her in one great blazing moment of summertime puberty when, during a visit to his aunt's farm in New York State, he attended a country fair. Markle peered inside a makeshift tattoo parlour to behold an indelible scene of a small angel, with breasts and wings, being drawn on the secret flesh of a woman's naked back.[5] By 1952, when the artist was just sixteen, he was riding his Harley from his hometown of Hamilton to "the American slime of border town Buffalo" and the infamous burlesque palaces: Club Savoy, The Moonglow, Palace Burlesque.[6] Jazz, booze and flaunted female flesh produced a heady rush of inspiration. Without a doubt the artist's model was very real, a working-class girl who stepped onto the stage to strut her ornamented "stuff" with a confidence born of her power to fulfil any fantasy. "[T]hose glistening dancers: blurring bodies." "My mark."[7]

Markle admitted the female nude in Art was erotic. He dropped any pretence of difference between high art and low life, and solicited an uncomfortable collusion

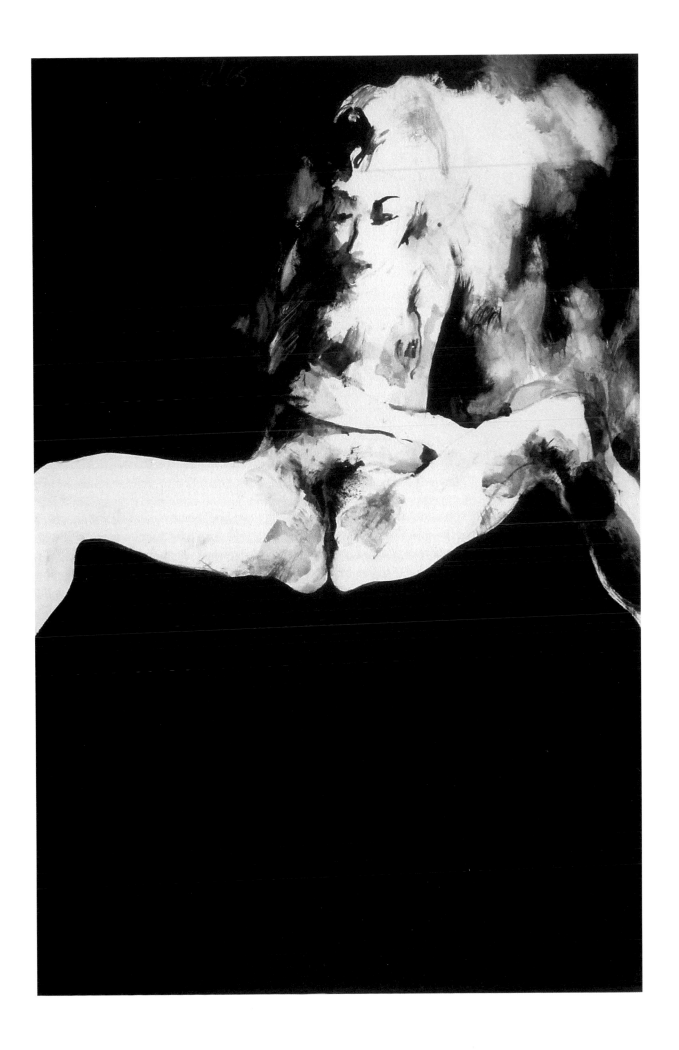

of love drawings. From the middle 1950s through the early 1960s, she scratched out scenes of "rushing eroticism" over the pages of Steno secretary notepads.[18] "I must...," Wieland wrote in her 1956 diary kept in France, "show in my work, what it is to love."[19] She paused at the potential literalness of her representations, and wondered about expressing love, "without drawing two people with their arms around one another."[20] "Everything I do is so personal," she claimed.[21] Like Markle, Wieland felt creativity intimately, close to her body and to her emotions. But the two artists viewed Art across the deep divide of their opposite sex.

By now Markle and Wieland might be yelling at one another across the room. Wieland, on one side, defending "the wonder and joy of having a [woman's] body."[22] Markle, on the other, letting slip: "Women... by their existence art is made."[23] "What?" Wieland should reply, puzzled by such flirtation. "She looked up at him with a smile so blessed that he felt surrounded," Markle would continue. "She was everything to him then, all his fantasies, all his desires."[24] "Who me?" Wieland would surely snort. She guarded love jealously. "It's not like in the movies," she would scold, "[W]e don't always grow up and get married and live happily."[25] In a pitch of frustration, Wieland would lock on target: "[M]y work is relegated to a woman's place, small, that is."[26]

Wieland's *Facing North-Self Impression* of 1973 (cat. no. 87, p. 77) is a funny and desperate document of a woman artist trying to see herself in Art. She pressed her face directly against the cool lithography stone and left her telltale mark. She looks

82.
Joyce Wieland and Betty Ferguson
Stills from *Barbara's Blindness*, 1965
17 minutes, colour, sound, 16mm film
Betty Ferguson, Puslinch, Ontario
© 2003 Betty Ferguson

blind in the print, unable "to see, really see."[27] In *Barbara's Blindness* (cat. no. 82, above) Wieland and Betty Ferguson's short film of 1965, the fair-haired little girl is blessed by a miraculous gift of sight. She sees only the bright and shining beauty of her own dreams, "the land of real belief." Early in her career Wieland had fancied the predicament of being a woman and, therefore, the subject of her own artistic gaze. In *Woman amusing herself* of c. 1955, she sits in her boudoir like the wicked witch in Snow White endlessly examining her face in the mirror. Now she wanted to step through the looking glass.

In truth, the reflection Wieland saw was in the gentleman's club mirror of the art worlds of New York (where she lived from 1962 to 1971) and Toronto. She smacked hard against it when she made *The Far Shore*, her feature film released in 1975. Wieland described the film as a Canadian love story, played out between Tom Thomson, the iconic wilderness landscape painter who represents the art world, and the fictitious character of Eulalie de Chicoutimi, an orphaned young woman, talented and slightly wild, in whom we see Wieland. *The Far Shore* pleased neither the public nor the critics. The doors of Art and its industries were guarded by the likes of Markle's muse, images of pure desire and an eroticism over which Wieland held no control. She was rebuffed and turned back out into the haunted woods of sixties womanhood, a synecdoche of generalized attributes and of flatlined femininity.[28] Jules Michelet's nineteenth-century pronouncement rang loudly: man creates history while woman "follows the noble and serene epic that Nature chants in her harmonious

cycles." "Nature is a woman."[29] Woman/nature, man/culture, and all the social fictions of Western society left Wieland reeling. She wondered about America's silent film sweetheart, Lillian Gish: "She is like an artist who draws pictures when she shapes herself…. In every scene she was outside herself seeing how she moves. It's incredible. I like her…."[30] "One is not born a woman," Simone de Beauvoir forever reminds us, "but, rather, becomes one."[31]

Wieland did understand seduction. She talked about film being a magical, seductive medium. In *Handtinting* (cat. no. 83, p. 71), her silent film of 1967–68, Wieland edited together outtakes from a film commissioned by the Xerox Corporation to document young women at a Job Corps training centre in West Virginia. What the artist found in Xerox's employee pool were "black kids who had come from everywhere." "They were lonely, rebellious, funny, restless and hopelessly poor."[32] These were economically, racially and sexually stratified women, humiliated by a corporate America who was deaf to their voices, blind to their individual oppression, and dumb on any issue of creativity. Wieland's film repeats images of the women dancing, swimming and in the locker room. Their figures are laterally flipped, then dyed, sewn and studied, to produce a rhythmic cadence of women's bodies.[33] The work is pure *écriture féminine*, sexual and unnervingly intimate.

The Victory Theatre, Toronto's "girlesk," "Canadian Burlesque at its polite best," was Markle's sixties stomping ground.[34] Sixteen-foot-high cut-out plywood "girls," with huge breasts, flanked the Victory stage, made a spectacle of his muse. His burlesque series of black-and-white drawings is a cinematic celebration of women dancing in space. Those were the days of pasties and overly large G-strings, when you had to be totally still on a slowly turning pedestal once you took everything off.[35] The audience, confined to their theatre seats, strained to catch a glimpse. "What are eyes for if not to act like hands," Markle said.[36] The strippers knew then what Judith Butler described thirty years later: it's a script, the gendered body is performative. Sex, Butler and her colleagues agree, is biologically intractable. Gender, however, is multivalent, an actualization of desire that is variable and incomplete without social interaction. "In other words, acts and gestures, articulated and enacted desires create the illusion of an interior and organizing gender core."[37] We have come to understand this predominantly in terms of heterosexuality, "real" men and "natural" women, the images with whom Markle and Wieland grappled.

Stripping got a lot more "gynecological" in Canada by the early eighties. McStrips proliferated, and the floor show fell short on gratification compared to private dances in Champagne Rooms. The changes began in 1973, when amendments to

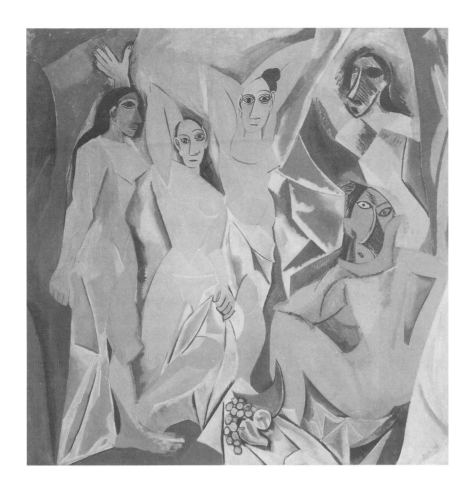

Ontario's Liquor Control Act brought alcohol and nudity together.[38] Maybe the skin trade got worse, or maybe it got better, but it certainly got competitive. The women got their tan lines and lost their tattoos, they shifted from club to club, and learned to be whomever you wanted, one-on-one. The first rule remains: always make sure the client thinks they are the one and only. Markle added his voyeuristic profile at "perv row" in his 1988 painting, *Time for the Floor* (cat. no. 37, p. 52). He revised *Les Demoiselles d'Avignon* (fig. 12, above), Picasso's homage to modernity of eighty years earlier, to redefine the worn out association "of female sexual experience with surrender and victimization."[39] Markle's *Time for the Floor* holds the man and woman in an infinite and private psychic realm. He's the leering "old Mohawk," who began to wear his Red Man Chewing Tobacco cap everywhere, and she's the stripper, a professional purveyor of fantasies.[40] It might seem like a sordid affair. Why not, Markle always worked against the grain of our prejudice, racial, sexual, or class, whatever.

Sexy Sadie worked Toronto's Yonge Street strip in the days before things got "cleaned up" at the end of the 1970s. Markle described her art of self-fascination, reaching out through the eyes of her audience to get a better look at herself.

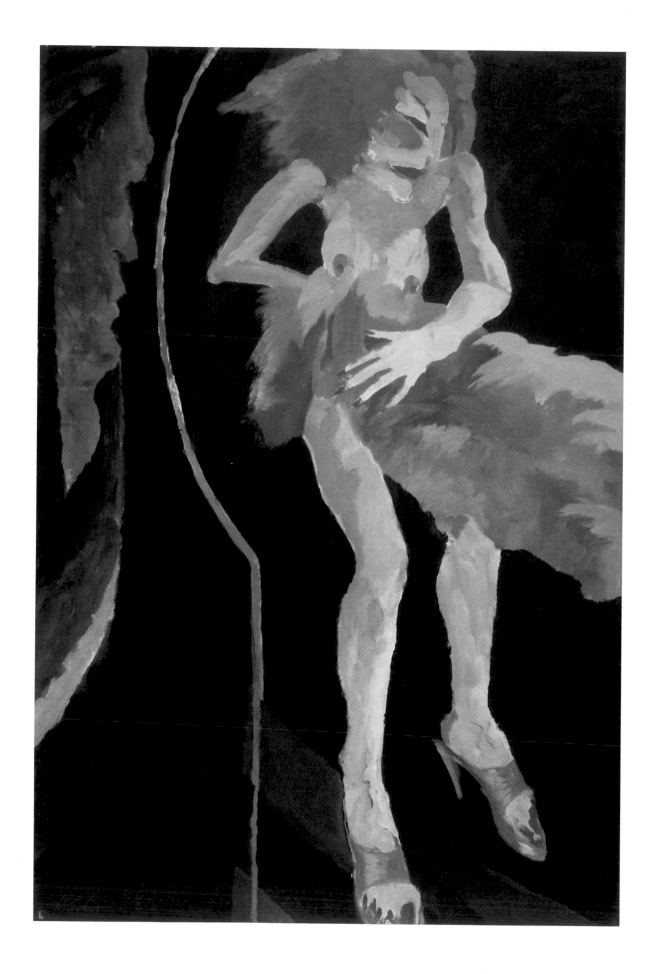

discovered Eve, Venus, Artemis, Sky Woman, and Mother Earth. She – the goddess, she – the creator, she – Art, and she – that glimpse of power, an internal sensation, by which we are all seduced. *Untitled (Goddess)* of 1984–86 (cat. no. 101, p. 74) is an affirmation of Wieland's identity. She is the giant fertile goddess frolicking in her favourite Newfoundland landscape. Her naked body and her libido, symbolized by menstrual blood, are her artistic agency. "The loss of divine representation...," argued Luce Irigary in 1988, "brought women to a state of dereliction." Recovering the goddess was a means of reestablishing a gynocratic tradition and of freeing women from a narrow vision of their creativity in terms of "a reproductive order – natural and spiritual – that is governed symbolically by men."[52] "My mother died when I was nine," recalled Wieland in a 1987 interview. The goddess "has to do with her" and a lifelong search to reconnect with her line.[53]

Wieland described her painting *Untitled (Goddess)* as "The Raw Tale for the Third World."[54] She was exploring global cultures for imagery of empowering creativity. Despite the criticism of Aboriginal writers for "the continuing hold of braids-and-feathers and Pocahontas 'Mother Earth' stereotypes," Wieland's whistling goddess, with feathers in her hair, is a forceful expression of self-respect.[55] She blurred the divisions between the artist, woman, creator and land in an ambitious and clearly risky allegory of Art. The union of Woman and Nature in Western thought rejected by feminism is reborn in *Untitled (Goddess)* through a more holistic interpretation offered in nonWestern traditions. *Godi' nigoh'*, the Women's Mind in Iroquoian culture, turns on Sky Woman and the creation story. "No matter how many varying creation stories have been told, are told, or will be told," writes Deborah Doxtator, "the central metaphor of the original Sky Woman with the uneasy mind falling to the world below and requiring union with land, earth, as her creative resolution, remains."[56] When Sky Woman fell to the water, continues Doxtator,

> [T]his world clearly began with an unsettled, restless mind searching for a solution to some sort of unresolved problem. This dissatisfied mind becomes the motivation for a creative act... and so it might very well become the catalyst for creative re-envisionings of how we perceive our intellectual connections to the world we live in now.[57]

Wieland made peace with Art when she resolved her image as a creative being. What about Markle? Are his wonder women the same as Wieland's goddesses? In their artistic maturity, did Markle and Wieland find in Art a reflection of their identity?

37.
Robert Markle
Time for the Floor, 1988
Acrylic on paper
111.8 x 75.9 cm
Art Gallery of Ontario, gift
of Marlene Markle, Holstein,
Ontario, 2001

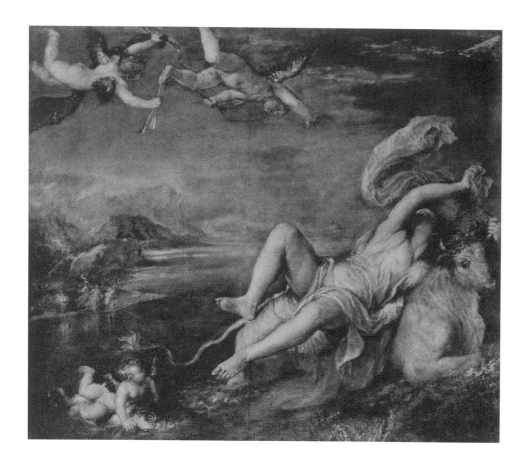

Fig.16
Titian
Italian, 1495–1579
Europa, c. 1575–80
Oil on canvas
58.0 x 96.0 cm
Isabella Stewart Gardner
Museum, Boston,
Massachusetts,
USA/Bridgeman Art Library

Suddenly, Markle (deadpan) starts:

> Nature he loved, and next to nature – nudes.
> He strove with every woman worth the strife,
> Warming both cheeks before the fire of life
> And fell, doing battle with a million prudes.[69]

Wieland laughs. Markle seizes the moment to declare: "I love restaurant food."
"Bobnoxious" (Robert's nickname) was on a roll. Stephen Centner hired Markle
to decorate his upscale hamburger joint on Toronto's Colborne Street in 1979.
Markleangelo's was a spin-off of serious Art, "a sexy Sistine Chapel, done up in
honky-tonk Baroque."[70] Markle's angels, neon-winged women of the strip, beckoned
customers to enjoy the pure carnal pleasures of "good Canadian cow." "Bread
whiter than my wife's thighs, all slowly submerging into a sea of steamy Van Dyke
[sic] brown gravy, ooohhh...." "When I contemplate the mysteries of the hot hamburger
sandwich," joked Markle in 1972, " – that complex juxtaposition of textures, shapes,
colours, tastes,... I'm reminded of what has been quite accurately said about women:
there are only three things you can do with a woman." "You can love her, suffer for her,
or you can turn her into art. Well, that goes double for *the hot hamburger sandwich.*"[71]

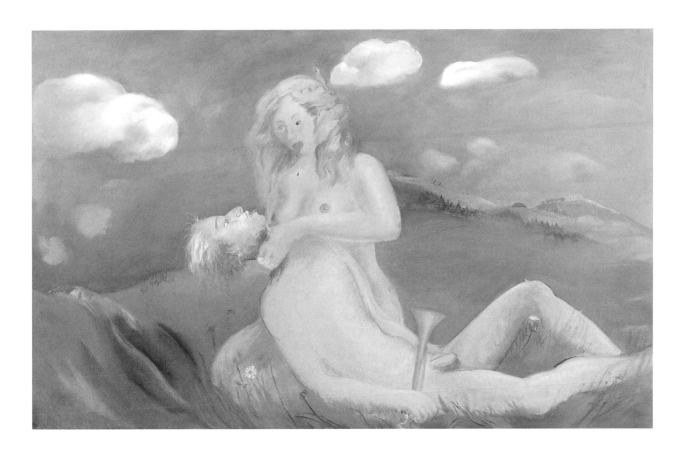

Wieland chooses her rejoinder carefully:

> Yours till the ocean wears rubber pants,
> To keep its bottom dry.[72]

Okay, okay, maybe this is getting off track, but "Life is not always serious."[73]
And happiness, Wieland hastens to add, always correcting the course of conversation
back to Art and what it means to be an artist, "Happiness is in the imagination."[74]
She sensed the fragility of this phrase, drawn late in life from her study of Mozart.
Images of creative frustration, her gut-wrenching struggle with Art in *Paint Phantom*
(cat. no. 100, p. 35), and an ironic reinterpretation of the Garden of Eden in *Untitled
(murderous angel)* (cat. no. 96, above) punctuate her last decade of artistic production.
They are reminders of Wieland's humanity and her extraordinary capacity to continually
remake herself. "Patterns of my energy as felt and pictured in my body" filled her
beautifully handmade sketchbook of the late 1980s.[75] Pure female energy whizzes
around the composition of *Menstrual Dance* (cat. no. 104, p. 76), a 1987 spoof on the
Three Graces of Greek mythology. Splendour, Mirth, and Good Cheer are the special
attendants of the divinities of love, Aphrodite and Eros. Wieland shows them dancing.
Markle keeps the beat, winking and singing, "Heaven's just a sin away...."[76]

96.
Joyce Wieland
Untitled (murderous angel),
between 1981 and 1984
Acrylic on canvas
112.0 x 172.6 cm
Sara Bowser Barney,
Toronto

Endnotes

1 Carol Duncan, "The Aesthetics of Power in Modern Art," *Heresies* (January 1977); in *Feminist Art Criticism: An Anthology*, eds. Arlene Raven, Cassandra L. Langer, Joanna Frueh (New York: Icon Editions, 1991), 62.

2 Ibid., 62.

3 Ibid., 62.

4 Robert Markle, "Artist Model," p. 3, Robert Markle fonds, series 2, box 5 (file 13), E.P. Taylor Research Library and Archives, Art Gallery of Ontario.

5 Robert Markle, "Blazing Figures (Part Two)," p. 5, Robert Markle fonds, series 2, box 7 (file 3), E.P. Taylor Research Library and Archives, Art Gallery of Ontario.

6 Robert Markle, untitled and undated manuscript, p. 27, Robert Markle fonds, series 2, box 7 (file 2), E.P. Taylor Research Library and Archives, Art Gallery of Ontario.

7 Ibid., 29.

8 Barrie Hale, "Master in a Hurry," *Toronto Telegram*, 18 July 1964.

9 Robert Fulford, "Drawings Hit High Standards," *Toronto Daily Star*, 30 April 1960.

10 Robert Fulford, " 'Community Standards' and Dorothy Cameron," *Toronto Daily Star*, 7 June 1967.

11 Charles T. Morey, "Law's Invasion of Art Shocking; Modern Erotica as Moral as Old Masters," *Toronto Daily Star*, 2 December 1965.

12 Betty Friedan, *The Feminine Mystique*, 1963; in *Sex 'n' Drugs 'n' Rock 'n' Roll: American Popular Culture since 1945*, ed. John N. Ingram (Toronto: University of Toronto Press, 1988), 202.

13 Joyce Wieland, 1990-014/004 (53), Joyce Wieland fonds, York University Archives and Special Collections; as quoted in Jane Lind, *Joyce Wieland: Artist on Fire* (Toronto: James Lorimer and Company Ltd., 2001), 99.

14 Leone Kirkwood, "Canadian Artist in New York Excels in Nameless Art Form," *The Globe and Mail*, 17 March 1965.

15 Joyce Wieland, York University guest lecture, [sound recording], 1 November 1972, 1993-009/012 (141), Joyce Wieland fonds, York University Archives and Special Collections.

16 Joyce Wieland, as quoted in Barrie Hale, *Toronto Telegram*, 11 March 1967.

17 Joyce Wieland and Hollis Frampton, untitled interview, p. 36, 1994-004/003 (01), Joyce Wieland fonds, York University Archives and Special Collections.

18 Robert Fulford, "World of Art: Franck, Wieland, Visitors," *Toronto Daily Star*, 3 February 1962.

19 Joyce Wieland, diary entry, 22 May 1956 – France, 1993-009/010 (114), Joyce Wieland fonds, York University Archives and Special Collections.

20 Joyce Wieland, diary entry, 9 June 1956 – France, 1993-009/010 (114), Joyce Wieland fonds, York University Archives and Special Collections.

21 Joyce Wieland, diary entry, 24 June 1956 – France, 1993-009/010 (114), Joyce Wieland fonds, York University Archives and Special Collections.

22 Ibid.

23 Robert Markle, untitled sketchbook notes, 1967, Robert Markle fonds, series 2, box 8, E.P. Taylor Research Library and Archives, Art Gallery of Ontario.

24 Robert Markle, "Draper Street," p. 21, Robert Markle fonds, series 2, box 6 (file 5), E.P. Taylor Research Library and Archives, Art Gallery of Ontario.

25 Joyce Wieland, 1990-014/004 (53), Joyce Wieland fonds, York University Archives and Special Collections; as quoted in Lind, *Joyce Wieland: Artist on Fire*, 99.

26 Joyce Wieland, as quoted in Debbie Magidson and Judy Wright, "Interviews with Canadian Artists," *The Canadian Forum* (May/June 1974), 61.

27 Joyce Wieland and Betty Ferguson, *Barbara's Blindness* [16mm film], 1965.

28 Butler states, "The identification of women with 'sex'... is a conflation of the category of women with the ostensibly sexualized features of their bodies and, hence, a refusal to grant freedom and autonomy to women as it is purportedly enjoyed by men. Thus, the destruction of the category of sex would be the destruction of an *attribute*, sex, that has, through a misogynist gesture of synecdoche, come to take the place of persons, the self-determining *cogito*." Judith Butler, *Gender Trouble: Feminism and Subversion of Identity*, (New York: Routledge, 1990), 19.

29 Jules Michelet, *Woman [La femme]*, trans. J. W. Palmer; as quoted in Duncan, "The Aesthetics of Power in Modern Art," 68.

30 Joyce Wieland, "A Collective Meditation: Joyce Wieland Speaks to István Antal," 1984, p. 7, 1988-003/001 (07), Joyce Wieland fonds, York University Archives and Special Collections.

31 Simone de Beauvoir, *The Second Sex*; as quoted in Butler, *Gender Trouble*, 8.

32 Joyce Wieland, as quoted in "Kay Armatage Interviews Joyce Wieland," *The Films of Joyce Wieland*, ed. Kathryn Elder (Toronto: Toronto International Film Festival Group, 1999), 154.

33 Kass Banning describes "the rhythmic cadence of the woman's body" in *Handtinting* as this silent film's "music." Kass Banning, "Textual Excess in Joyce Wieland's Handtinting," *The Films of Joyce Wieland*, 131.

34 Robert Markle, "Blazing Figures (Part Two)," p. 9, Robert Markle fonds, series 2, box 7 (file 3), E.P. Taylor Research Library and Archives, Art Gallery of Ontario.

35 Janet Feindel, *A Particular Class of Women* (Vancouver: Lazara Publications, 1988), 47.

36 Robert Markle, untitled and undated manuscript, unpaginated, Robert Markle fonds, series 2, box 7 (file 1), E.P. Taylor Research Library and Archives, Art Gallery of Ontario.

37 Judith Butler, *Gender Trouble*, 136.

38 Chris Bruckert, *Taking it off, Putting it on: Women in the Strip Trade* (Toronto: Women's Press, 2002), 59.

39 Duncan, "The Aesthetics of Power in Modern Art," 60.

40 Robert Markle, notes for a radio show, undated and unpaginated, Robert Markle fonds, series 2, box 5 (file 12), E.P. Taylor Research Library and Archives, Art Gallery of Ontario.

41 Robert Markle, "Notes Toward *The Night is Falling on Lady Day*," p. 6, Robert Markle fonds, series 2, box 7 (file 3), E.P. Taylor Research Library and Archives, Art Gallery of Ontario.

42 Robert Markle, "The Moral Shape of Sexy Sadie," *Toronto Life* (October 1977), 59.

43 Robert Markle, untitled and undated manuscript, p. 3, Robert Markle fonds, series 2, box 7 (file 2), E.P. Taylor Research Library and Archives, Art Gallery of Ontario.

44 Markle, "The Moral Shape of Sexy Sadie," 128.

45 Ibid., 59.

46 Wollheim describes the physical relationship Willem de Kooning demands one to establish with his work as the source of content or meaning. The artist treats the painting metaphorically "as a box or container, objects of the sense other than sight." Richard Wollheim, "Painting, Metaphor, and the Body: Titian, Bellini, De Kooning, etc.," in *Painting as an Art* (New Jersey: Princeton University Press, 1987), 348–50.

47 Markle, "The Moral Shape of Sexy Sadie," 59.

48 Joyce Wieland, untitled and undated loose sheet, 1993-009/010(120), Joyce Wieland fonds, York University Archives and Special Collections.

49 French artist Yves Klein (1928–1962) orchestrated a number of performance works that were enactments of his concept of the *femme pinceau*. Most famous was *Performance anthropométrie de l'époque bleue* at Galerie Internationale d'Art Contemporain in Paris in March of 1960. Three naked female models were covered in his signature IKB (International Klein Blue) paint. The imprint of their bodies were called *anthropométries*. The women's torsos became an extension of the phallic brush, over which Klein had control. See Lynda Nead, *The Female Nude: Art, Obscenity, and Sexuality* (London: Routledge, 1992), 72–3.

50 Robert Markle, as quoted in Janice Hendrick, "Robert Nelson Markle, 1936–1990," *SiteSound* (September 1990), 14.

51 Hildegard von Bingen, as quoted in Thomas Laqueur, *Making Sex: Body and Gender from the Greeks to Freud* (Cambridge, Mass.: Harvard University Press, 1990), 120.

52 Luce Irigary, "How Can We Create Our Beauty?" in *je, tu, nous: toward a culture of difference*, trans. Alison Martin (New York: Routledge), 111.

53 Joyce Wieland, as quoted in Eimear O'Neill, "Joyce Wieland 'An Interview'," *Canadian Woman Studies*, 8 (Winter 1987), 35.

54 Joyce Wieland, "A Collective Meditation," 7.

55 A. Robert Lee, Introduction in Gerald Vizenor and A. Robert Lee, *Postindian Conversations* (Lincoln: University of Nebraska Press, 1999), 5.

56 Deborah Doxtator, "Godi'Nigoha': The Women's Mind and Seeing Through to the Land," in *Godi' Nigoha', The Women's Mind* (Brantford: Woodland Cultural Centre, 1997), 29.

57 Ibid., 29.

58 Robert Markle, untitled and undated manuscript, unpaginated, Robert Markle fonds, series 2, box 6 (file 2), E.P. Taylor Research Library and Archives, Art Gallery of Ontario.

59 Robert Markle, rough notes for a "Heritage Minute" script on Iroquoian Confederacy, Robert Markle fonds, series 2, box 5 (file 1), E.P. Taylor Research Library and Archives, Art Gallery of Ontario.

60 Gerald Vizenor, with A. Robert Lee, "Discursive Narratives," *Postindian Conversations*, 84–5.

61 Robert Markle, untitled and undated manuscript, p. 30, Robert Markle fonds, series 2, box 7 (file 2), E.P. Taylor Research Library and Archives, Art Gallery of Ontario.

62 Robert Markle, "Portrait," unpaginated, Robert Markle fonds, series 2, box 7 (file 2), E.P. Taylor Research Library and Archives, Art Gallery of Ontario.

63 Robert Markle, untitled and undated manuscript, unpaginated, Robert Markle fonds, series 2, box 7 (file 1), E.P. Taylor Research Library and Archives, Art Gallery of Ontario.

64 Markle, "The Moral Shape of Sexy Sadie," 126.

65 Robert Markle, "Blazing Figures (Part One)," p. 18, Robert Markle fonds, series 2, box 7 (file 3), E.P. Taylor Research Library and Archives, Art Gallery of Ontario.

66 Robert Markle, "Blazing Figures (Part Three)," p. 5, Robert Markle fonds, series 2, box 7 (file 3), E.P. Taylor Research Library and Archives, Art Gallery of Ontario.

67 Robert Markle, "Blazing Figures (Part One)," p. 9, Robert Markle fonds, series 2, box 7 (file 3), E.P. Taylor Research Library and Archives, Art Gallery of Ontario.

68 Markle, "The Moral Shape of Sexy Sadie," 59.

69 Robert Markle, "Blazing Figures (Part One)," p. 24, Robert Markle fonds, series 2, box 7 (file 3), E.P. Taylor Research Library and Archives, Art Gallery of Ontario.

70 John Bentley Mays, "Relishing Hamburger Art," *The Globe and Mail*, 3 May 1980.

71 Robert Markle, revised notes for "Great Hot Hamburger Sandwiches," p. 14, Robert Markle fonds, series 2, box 5 (file 9), E.P. Taylor Research Library and Archives, Art Gallery of Ontario.

72 Gloria Fox to Joyce Wieland, [autograph book], 8 September 1943, 1988-003/003 (44), Joyce Wieland fonds, York University Archives and Special Collections.

73 Joyce Wieland, interview, [sound recording], 1970s, 1993-009/012 (142), Joyce Wieland fonds, York University Archives and Special Collections.

illustrations

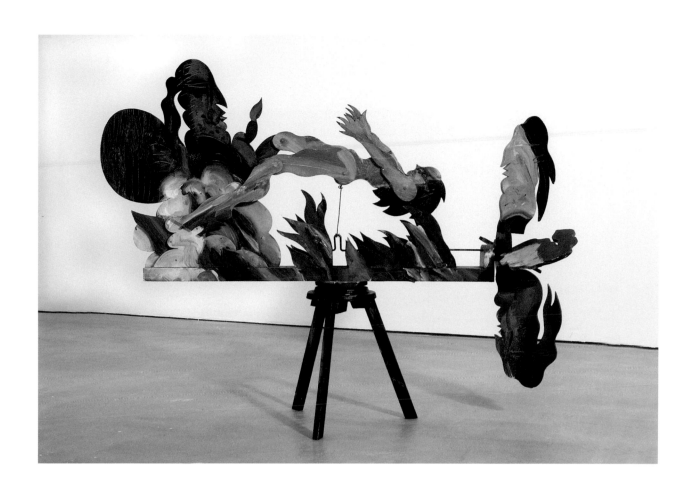

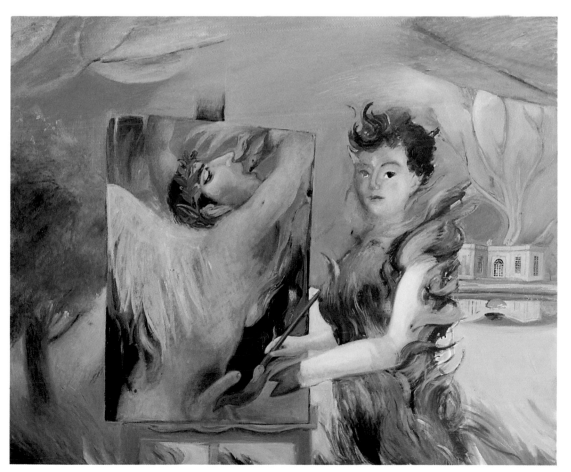

35.
Robert Markle
Creation (whirligig), 1988
Acrylic, wood
123.0 x 94.0 x 157.0 cm
Thunder Bay Art Gallery
Collection, private donation

99.
Joyce Wieland
Artist on Fire, 1983
Oil on canvas
107.2 x 130.0 cm
Collection of the Robert
McLaughlin Gallery,
Oshawa, purchase, 1984

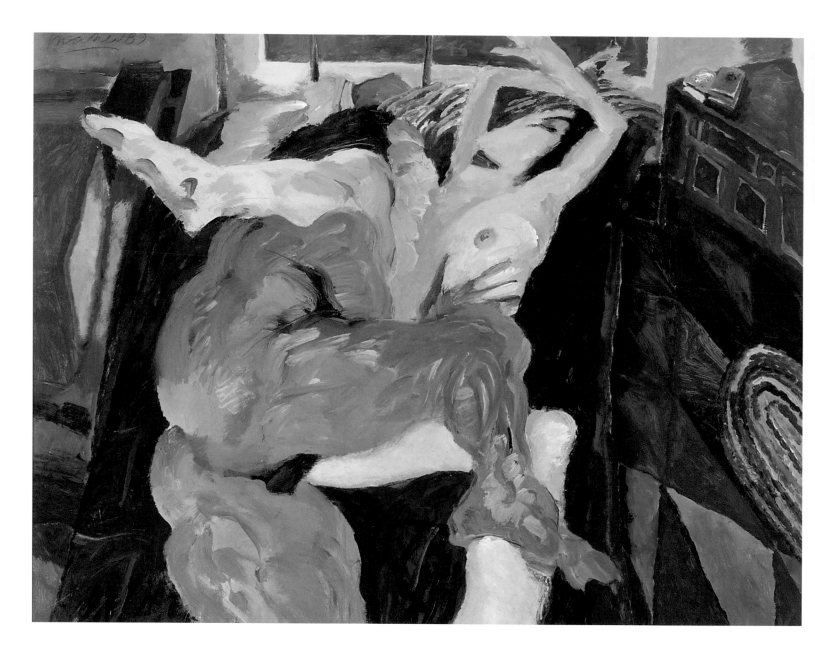

41.
Robert Markle
A Likeness of Being, 1989
Acrylic on tempered
hardboard
92.4 x 122.2 cm
Marlene Markle, Holstein,
Ontario

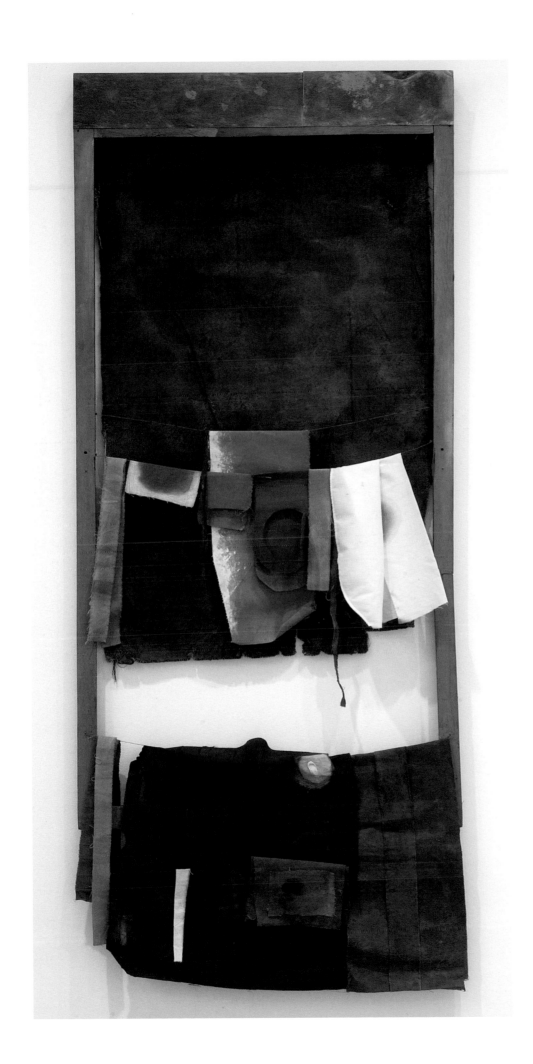

77.
Joyce Wieland
Clothes of Love, 1960–61
Mixed media assemblage
151.5 x 76.0 cm
Rachel Barney, Toronto

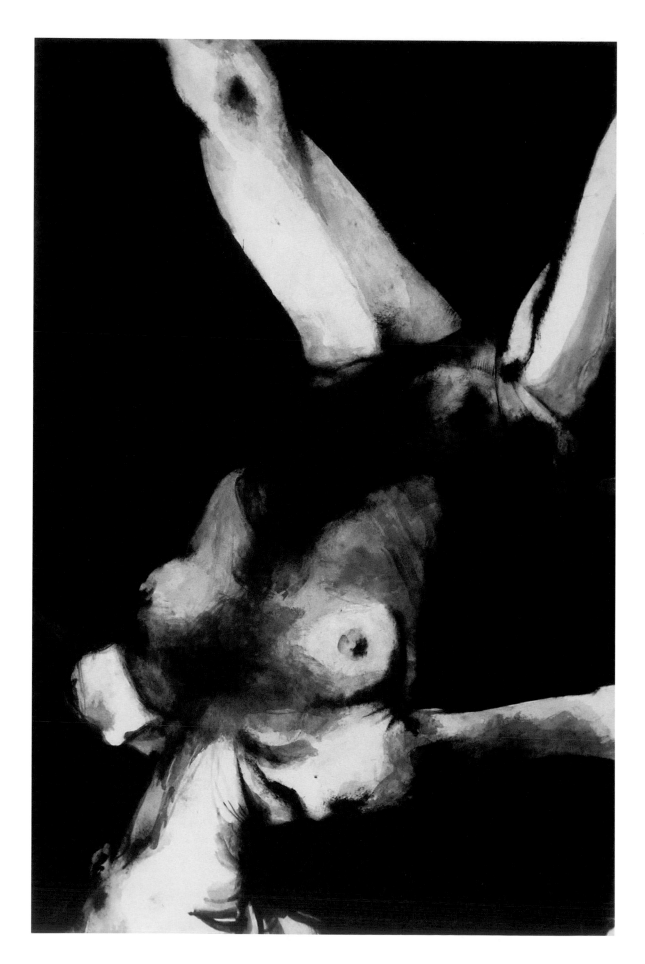

5.
Robert Markle
Burlesque Series VI, 1963
Tempera on paper
88.6 x 58.5 cm
Art Gallery of Ontario,
purchased with funds
donated by AGO Members,
2001

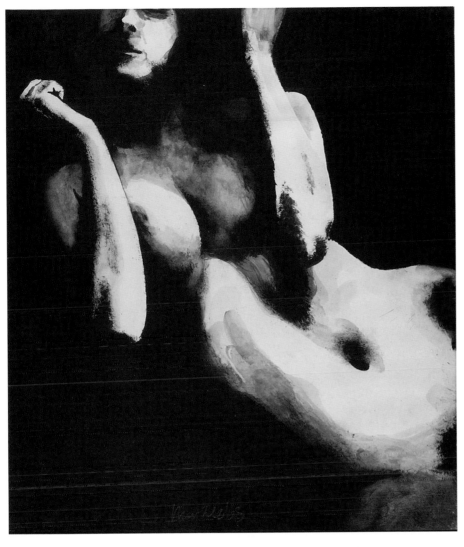

6.
Robert Markle
Burlesque Series VII, 1963
Tempera on paper
49.5 x 58.5 cm
Courtesy of The Isaacs
Gallery, Toronto

8.
Robert Markle
*Burlesque Series: Victory
Dance,* 1963
Tempera on paper
58.5 x 88.4 cm
Art Gallery of Ontario,
purchased with funds
donated by AGO Members,
2001

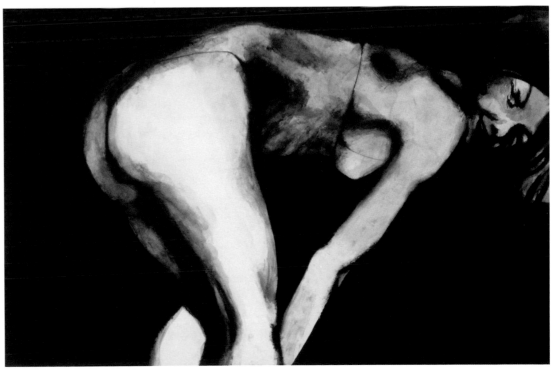

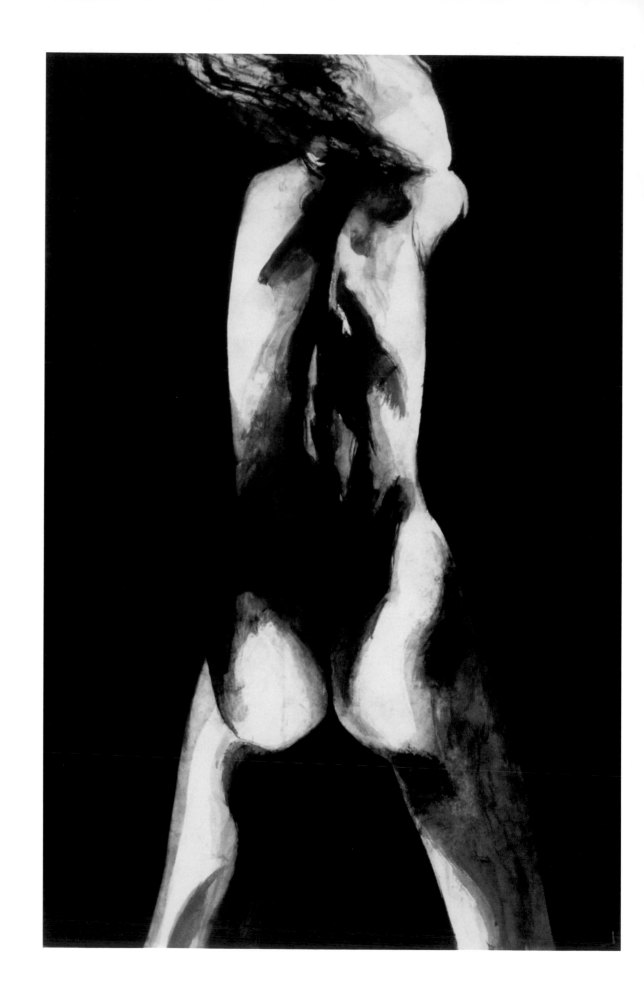

9.
Robert Markle
Burlesque Series, 1963
Tempera on wove paper
89.1 x 58.7 cm
Art Gallery of Ontario,
purchased with funds
donated by AGO Members,
2001

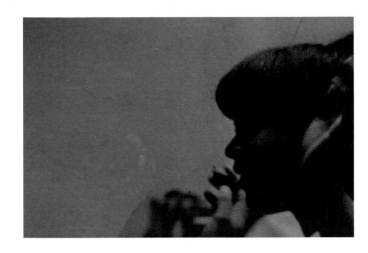

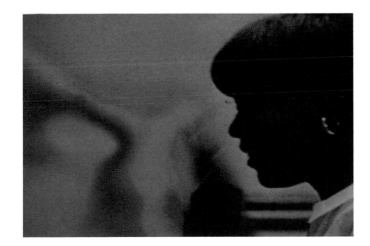

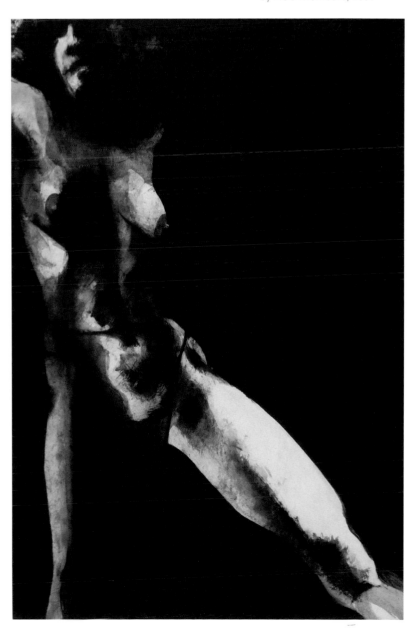

85.
Joyce Wieland
Bear and Spirit of Canada,
1970–71
Bronze
7.5 x 13.3 x 20.0 cm
Munro Ferguson, Montreal

84. Joyce Wieland
The Spirit of Canada
Suckles the French and
English Beavers, 1970–71
Bronze
6.0 x 9.3 x 19.3 cm
Jean Sutherland Boggs,
Westmount, Quebec

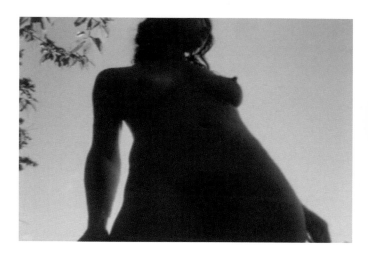

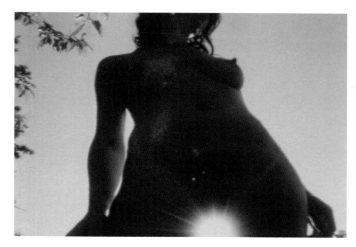

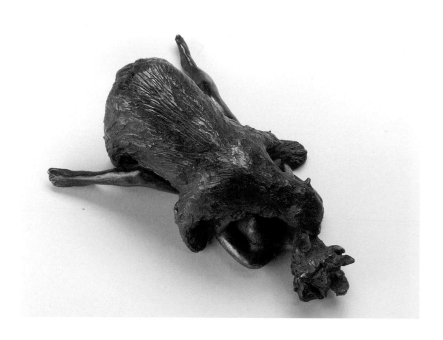

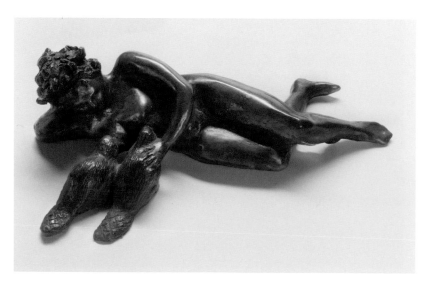

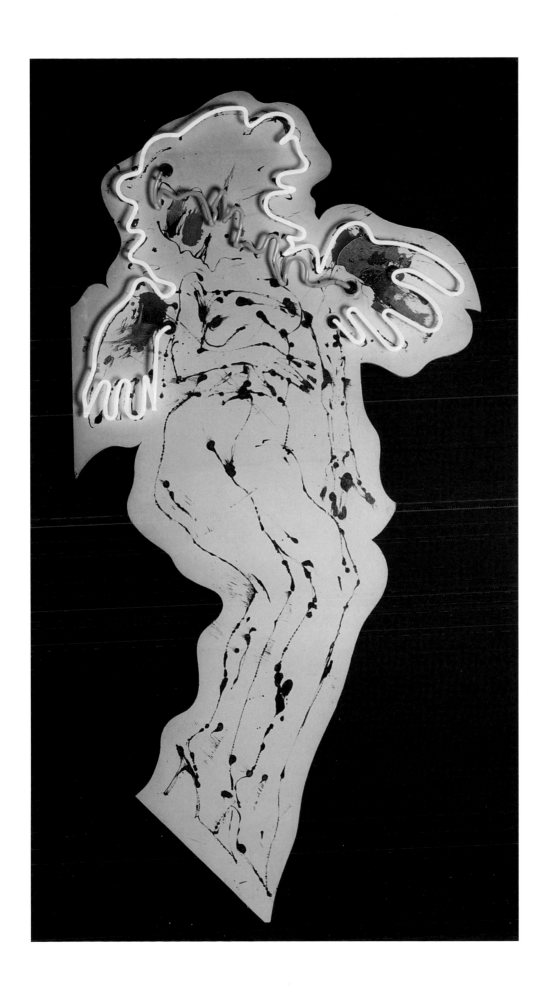

12.
Robert Markle
Stills from *Untitled
(Landscape with Nude –
Marlene)*, between 1964 and
1968
25 minutes, black and white,
silent, 8 mm film
Robert Markle fonds,
series 18, box 30, E.P. Taylor
Research Library and
Archives

30.
Robert Markle
Angel (from Markleangelo's),
1979–80
Acrylic and neon on wood
235.5 x 113.0 x 24.0 cm
Robert McLaughlin Gallery,
Oshawa, gift of R. Partyka
and Associates, 1983

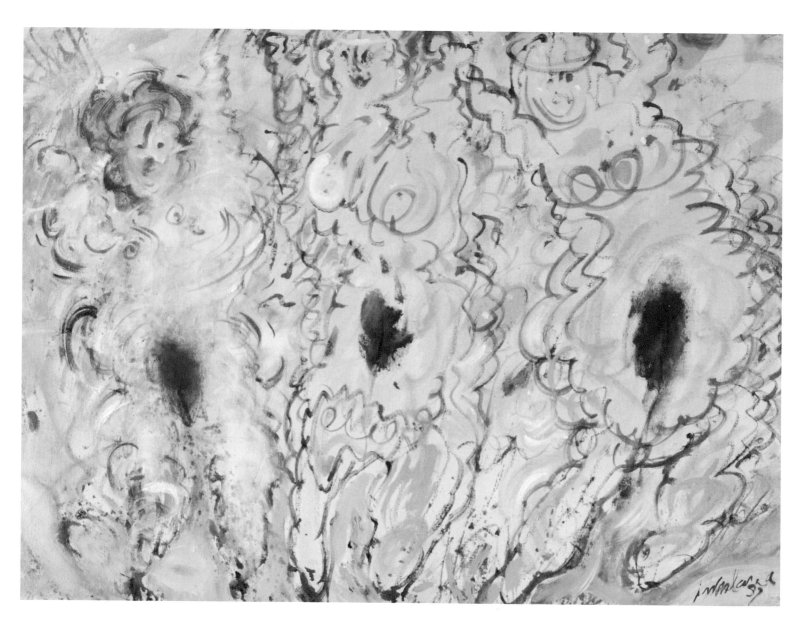

104.
Joyce Wieland
Menstrual Dance, 1987
Oil on canvas
86.6 x 117.1 cm
Betty Ferguson, Puslinch,
Ontario

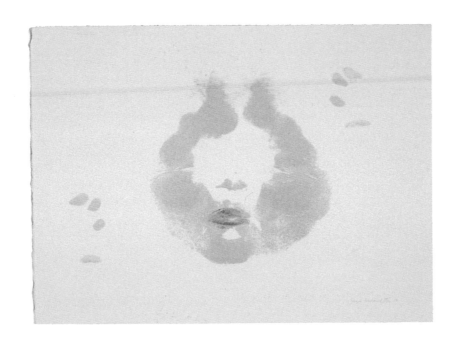

87.
Joyce Wieland
Facing North-Self Impression, 1973
Lithograph on paper
33.1 x 43.6 cm
Art Gallery of Ontario
purchase, 1987

93.
Joyce Wieland
Untitled (bather and hare),
between 1980 and 1982
Graphite and coloured
pencil on paper
29.5 x 38.8 cm
Art Gallery of Ontario,
gift of Betty Ramsaur
Ferguson, Puslinch, Ontario,
1998

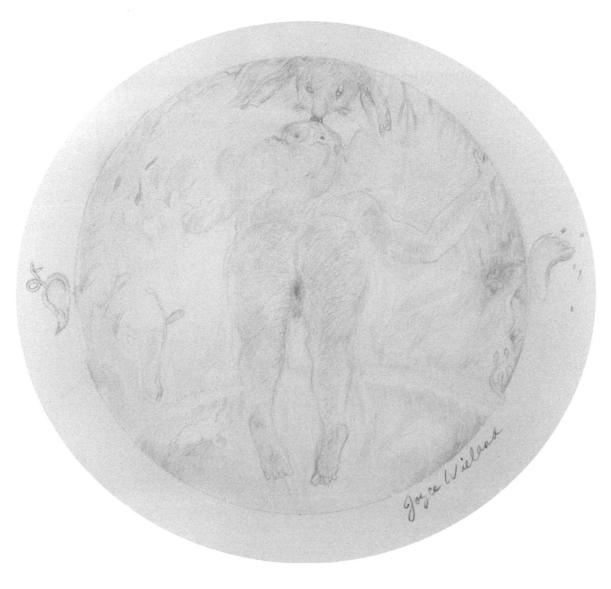

75.
Joyce Wieland
Redgasm, 1960
Oil on canvas
71.5 x 117.0 cm
Mr. and Mrs. Herzig, Toronto

95.
Joyce Wieland
Victory of Venus, 1981
Coloured pencil on paper
48.4 x 61.0 cm
Art Gallery of Ontario,
purchased with funds
donated by AGO Members,
2002

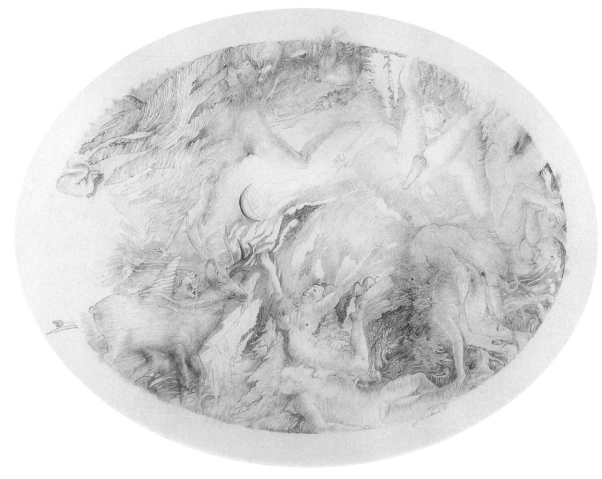

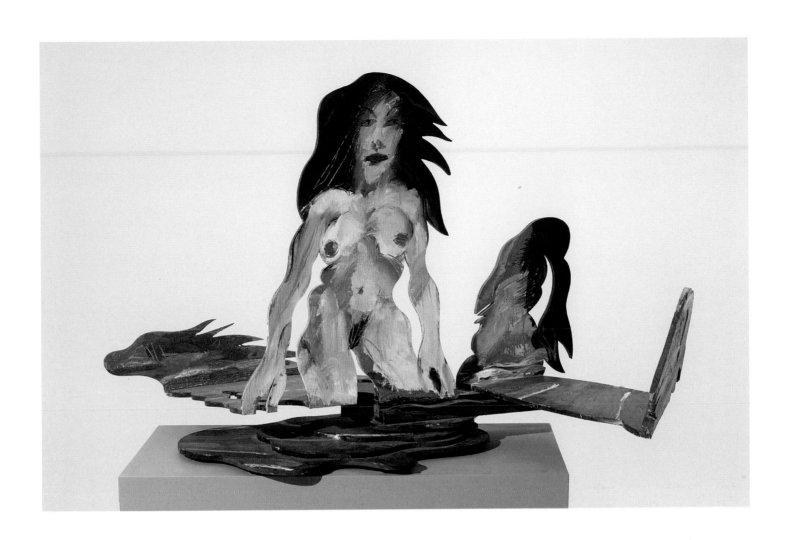

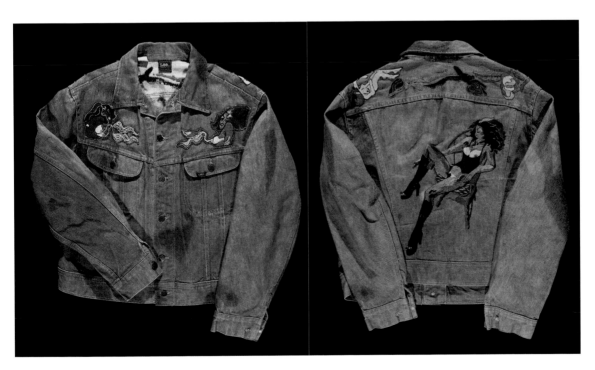

36.
Robert Markle
River (whirligig), 1988
Acrylic, wood
80.5 x 49.5 x 146.0 cm
Marlene Markle, Holstein,
Ontario

25.
Robert Markle
*Denim suit (Lee jeans and
jacket)*, c. 1975
Cotton, embroidery floss,
glass beads
Robert Markle fonds, series
17, box 25, E.P. Taylor
Research Library and
Archives, Art Gallery of
Ontario

34.
Robert Markle
Untitled (after Matisse),
c. 1985
Pastel, coloured inks and
acrylic on paper
58.6 x 88.9 cm
Art Gallery of Ontario, gift
of Marlene Markle, Holstein,
Ontario, 2001

102.
Joyce Wieland
Mozart and Wieland, 1985
Oil on canvas
137.2 x 129.6 cm
Private collection, Ottawa

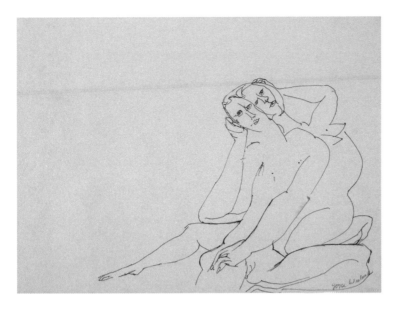

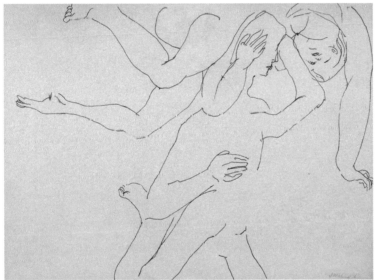

52.
Joyce Wieland
Untitled (lovers joined),
between 1954 and 1958
Ink on paper
21.5 x 28.0 cm
Art Gallery of Ontario, gift
of Betty Ramsaur Ferguson,
Puslinch, Ontario, 1998

57.
Joyce Wieland
Lovers, 1956
Ink on paper
21.5 x 27.9 cm
Art Gallery of Ontario, gift
of Betty Ramsaur Ferguson,
Puslinch, Ontario, 1998

56.
Joyce Wieland
Untitled (play), 1956
Ink on paper
13.6 x 20.7 cm
Art Gallery of Ontario, gift
of Betty Ramsaur Ferguson,
Puslinch, Ontario, 1998

63.
Joyce Wieland
Lovers, 1956
Ink on paper
13.7 x 21.1 cm
Art Gallery of Ontario, gift
of Betty Ramsaur Ferguson,
Puslinch, Ontario, 1998

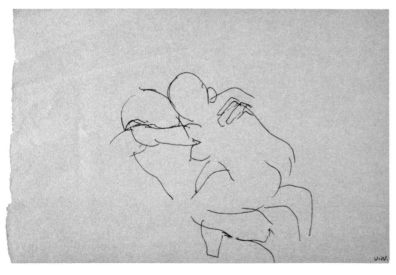

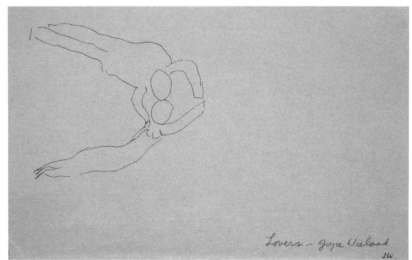

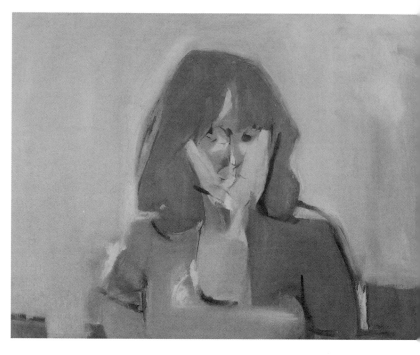

47.
Joyce Wieland
Self-Portrait, c. 1949
Oil on canvas board
61.0 x 50.9 cm
Michael Wieland,
Orangeville, Ontario

68.
Joyce Wieland
Myself, 1958
Oil on canvas
56.0 x 71.9 cm
Paul and Margaret Break,
Toronto

88.
Joyce Wieland
Self-Portrait, 1978
Oil on canvas
20.6 x 20.3 cm
Agnes Etherington Art
Centre, Queen's University,
Kingston, Purchase,
Chancellor Richardson
Memorial Fund, 1993

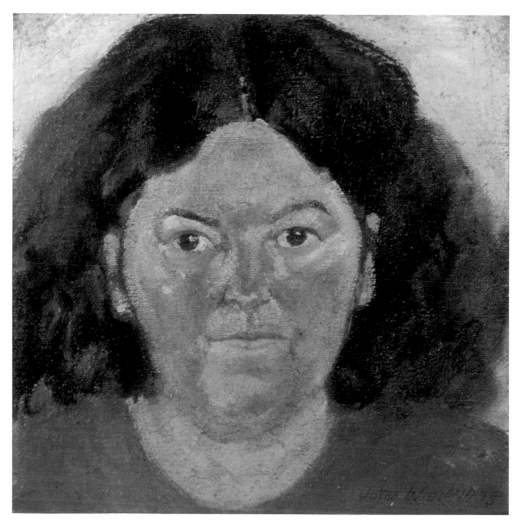

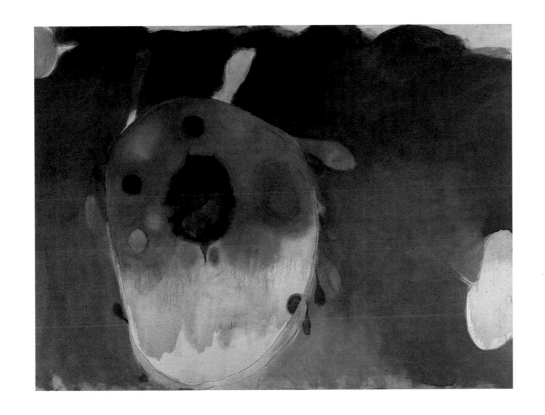

78.
Joyce Wieland
Time Machine Series, 1961
Oil on canvas
203.2 x 269.9 cm
Art Gallery of Ontario,
gift from the McLean
Foundation, 1966

81.
Joyce Wieland
Penis Wallpaper, 1962
Oil on canvas
20.1 x 23.1 cm
Mr. and Mrs. L. Lawrence,
Toronto

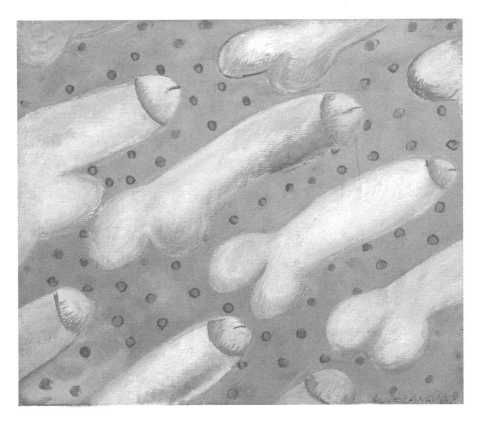

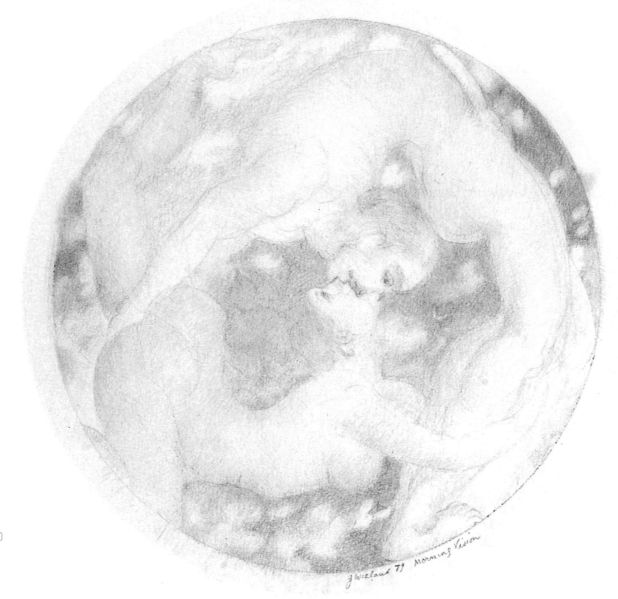

90.
Joyce Wieland
Morning Vision, 1979
Coloured pencil on paper
27.9 x 31.8 cm
Paul and Joyce Chapnick,
Toronto

43.
Robert Markle
Rooms: The West Wall, 1990
Acrylic on tempered
hardboard
46.9 x 203.5 cm
Marlene Markle, Holstein,
Ontario

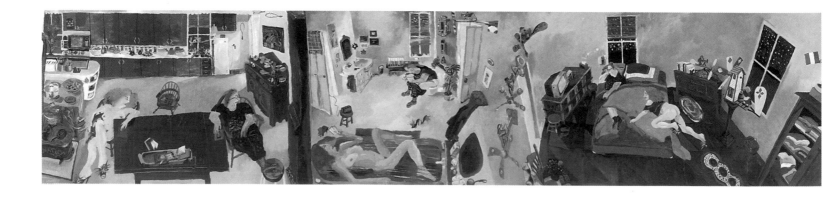

76.
Joyce Wieland
Spring Blues, 1960
Collage: oil paint, paper and
mirror fragments on canvas
117.5 x 82.1 cm
Douglas MacPherson,
Toronto

74
Joyce Wieland
The Kiss, 1960
Oil on canvas
81.4 x 63.5 cm
Vancouver Art Gallery;
gift of Donna Montague

14.
Robert Markle
Untitled, 1965
Charcoal on paper
58.7 x 89.0 cm
Marlene Markle, Holstein,
Ontario

1.
Robert Markle
Untitled (model),
between 1958 and 1960
Oil on canvas
91.5 x 71.2 cm
Judith Donoahue, Brechin,
Ontario

2.
Robert Markle
Untitled, 1962
Ink on paper
60.5 x 47.8 cm
Marlene Markle, Holstein,
Ontario

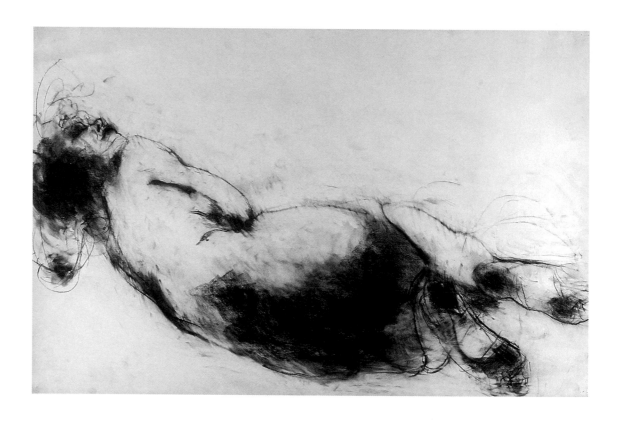

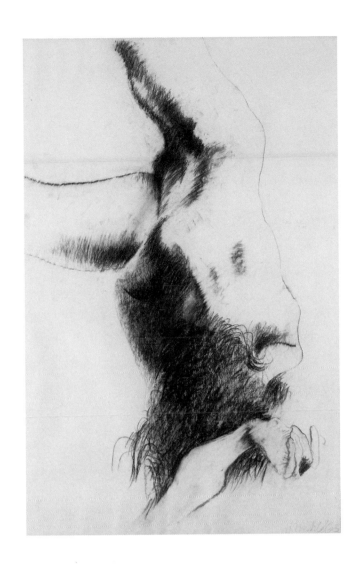

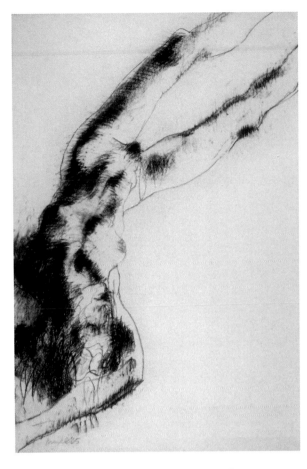

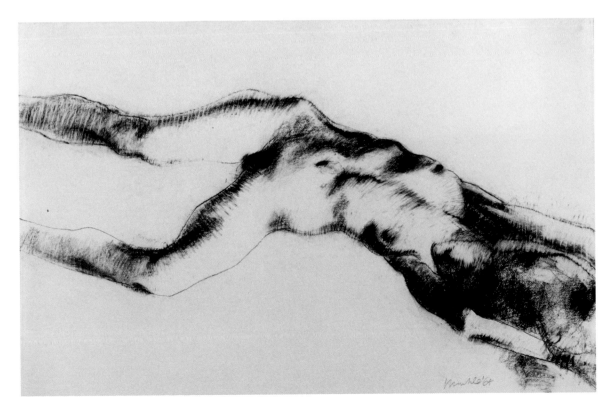

3.
Robert Markle
Reclining Figure, 1963
Charcoal on paper
89.1 x 58.6 cm
Courtesy of The Isaacs
Gallery, Toronto

13.
Robert Markle
Falling Figure Series, 1965
Charcoal on paper
89.1 x 58.6 cm
Art Gallery of Ontario,
purchased with funds
donated by AGO Members,
2001

11.
Robert Markle
*Falling Figure Series:
Marlene III,* 1964
Charcoal on paper
58.4 x 88.9 cm
Art Gallery of Ontario,
anonymous gift in honour
of J.W.G. (Jock) Macdonald,
1965

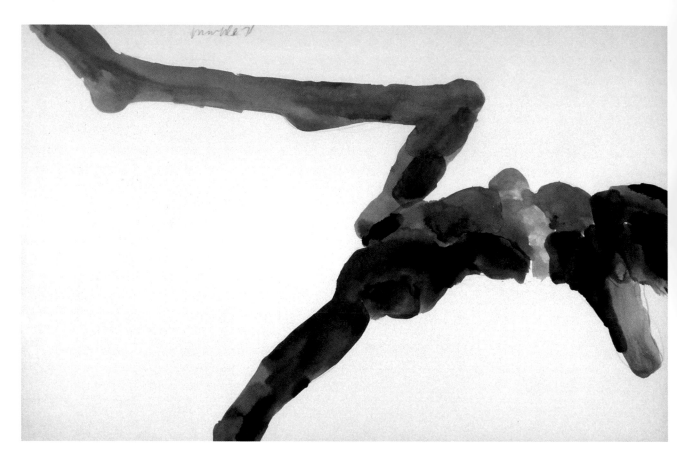

28.
Robert Markle
Stretch, 1971
Graphite and coloured
inks on paper
58.7 x 89.0 cm
Art Gallery of Ontario,
gift of Marlene Markle,
Holstein, Ontario, 2001

98.
Joyce Wieland
Artemis, 1983
10 colour photocopies,
each 21.6 x 27.9 cm
Michael Wieland,
Orangeville, Ontario

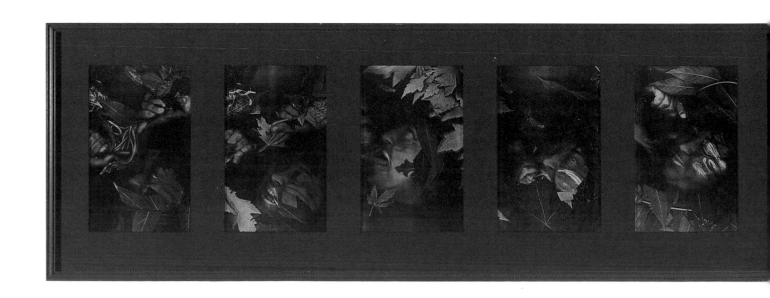

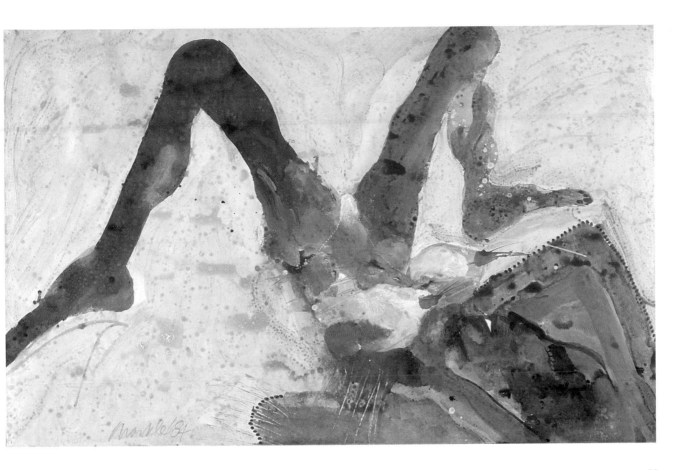

33.
Robert Markle
Cushioned Corner, 1984
Coloured inks and acrylic
on paper
66.0 x 102.0 cm
Courtesy of The Isaacs
Gallery, Toronto

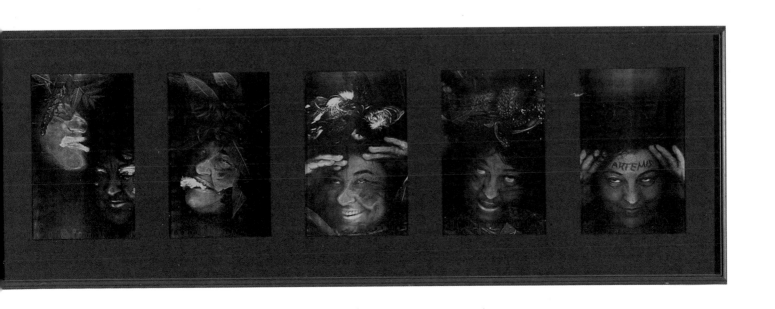

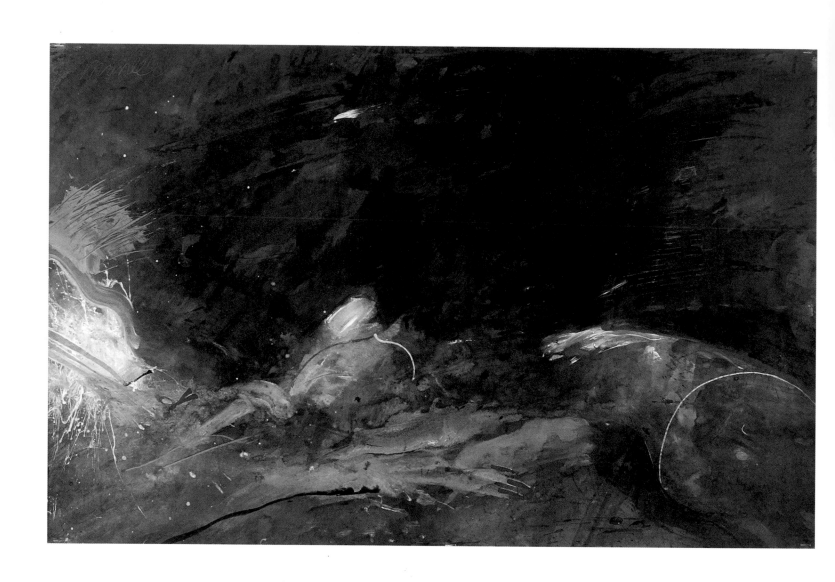

32.
Robert Markle
*Zanzibar Series:
Brainstorming*, 1981
Coloured inks and acrylic
on paper
66.0 x 101.2 cm
Andrew Wainwright and
Marjorie Stone, Halifax

list of works in the exhibition

Robert Markle (1936–1990)

1.
Untitled (model), between 1958 and 1960
Oil on canvas
91.5 x 71.2 cm
Judith Donoahue, Brechin, Ontario

2.
Untitled, 1962
Ink on paper
60.5 x 47.8 cm
Marlene Markle, Holstein, Ontario

3.
Reclining Figure, 1963
Charcoal on paper
89.1 x 58.6 cm
Courtesy of The Isaacs Gallery, Toronto

4.
Untitled, 1963
Charcoal and tempera on paper
60.3 x 47.6 cm
Marlene Markle, Holstein, Ontario

5.
Burlesque Series VI, 1963
Tempera on paper
88.6 x 58.5 cm
Art Gallery of Ontario, purchased with
funds donated by AGO Members, 2001
2001/7

6.
Burlesque Series VII, 1963
Tempera on paper
49.5 x 58.5 cm
Courtesy of The Isaacs Gallery, Toronto

7.
Burlesque Series XII, 1963
Tempera on paper
89.1 x 58.6 cm
Art Gallery of Ontario, purchased with
funds donated by AGO Members, 2001
2001/8

8.
Burlesque Series: Victory Dance, 1963
Tempera on paper
58.5 x 88.4 cm
Art Gallery of Ontario, purchased with
funds donated by AGO Members, 2001
2001/9

9.
Burlesque Series, 1963
Tempera on paper
89.1 x 58.7 cm
Art Gallery of Ontario, purchased with
funds donated by AGO Members, 2001
2001/10

10.
Lovers II, 1963
Tempera on paper
58.6 x 89.1 cm
Art Gallery of Ontario, purchased with
funds donated by AGO Members, 2001
2001/11

11.
Falling Figure Series: Marlene III, 1964
Charcoal on paper
58.4 x 88.9 cm
Art Gallery of Ontario, anonymous gift in
honour of J.W.G. (Jock) Macdonald, 1965
64/40

12.
Untitled (Landscape with Nude – Marlene),
between 1964 and 1968
25 minutes, black and white, silent,
8 mm film
Robert Markle fonds, series 18, box 30
E.P. Taylor Research Library and Archives,
Art Gallery of Ontario

13.
Falling Figure Series, 1965
Charcoal on paper
89.1 x 58.6 cm
Art Gallery of Ontario, purchased with
funds donated by AGO Members, 2001
2001/13

14.
Untitled, 1965
Charcoal on paper
58.7 x 89 cm
Marlene Markle, Holstein, Ontario

15.
Paramour, 1965
Charcoal and tempera on paper
89.1 x 58.4 cm
Art Gallery of Ontario, purchased with
funds donated by AGO Members, 2001
2001/12

16.
Untitled, 1966
Charcoal on paper
58.4 x 88.9 cm
Marlene Markle, Holstein, Ontario

17.
Pale Blue Marlene, 1968
Tempera on paper
88.9 x 58.4 cm
Marlene Markle, Holstein, Ontario

18.
Pale Blue Marlene, 1968
Tempera on paper
88.9 x 58.4 cm
Marlene Markle, Holstein, Ontario

19.
Pale Blue Marlene, 1968
Tempera on paper
88.9 x 58.4 cm
Marlene Markle, Holstein, Ontario

20.
Untitled, 1968
Charcoal and tempera on paper
58.4 x 88.9 cm
Marlene Markle, Holstein, Ontario

21.
Untitled, 1968
Charcoal and tempera on paper
58.6 x 88.8 cm
Art Gallery of Ontario, gift of Marlene
Markle, Holstein, Ontario, 2001
2001/440

22.
Untitled, c. 1970
Charcoal on paper
Strathmore Alexis drawing pad
Robert Markle fonds, series 12, box 20,
E.P. Taylor Research Library and Archives,
Art Gallery of Ontario

23.
Untitled, between 1970 and 1975
Coloured inks on paper
Sketchbook 3
Robert Markle fonds, series 12, box 19,
E.P. Taylor Research Library and Archives,
Art Gallery of Ontario

24.
Untitled, between 1970 and 1972
Coloured inks on paper
Sketchbook 2
Robert Markle fonds, series 12, box 18,
E.P. Taylor Research Library and Archives,
Art Gallery of Ontario

25.
Denim suit (Lee jeans and jacket), c. 1975
Cotton, embroidery floss, glass beads
Robert Markle fonds, series 17, box 25
E.P. Taylor Research Library and Archives,
Art Gallery of Onartio

26.
High Step, 1971
Coloured inks on paper
58.4 x 88.9 cm
Marlene Markle, Holstein, Ontario

27.
Sunpose II, 1971
Graphite and coloured inks on paper
58.6 x 89.1 cm
Art Gallery of Ontario, gift of Marlene
Markle, Holstein, Ontario, 2001
2001/441

28.
Stretch, 1971
Graphite and coloured inks on paper
58.7 x 89.0 cm
Art Gallery of Ontario, gift of Marlene
Markle, Holstein, Ontario, 2001
2001/442

29.
*Untitled (Self-Portraits at the Pilot
Tavern)*, c. 1975
Porous pointed pen on paper
Five coasters, each 10.0 cm diameter
Paul and Margaret Break, Toronto

30.
Angel (from Markleangelo's), 1979–80
Acrylic and neon on wood
235.5 x 113.0 x 24.0 cm
Robert McLaughlin Gallery, Oshawa, gift of
R. Partyka and Associates, 1983

31.
Zanzibar Series: Paint, Powder and Rouge,
1981
Coloured inks and acrylic on paper
66.0 x 101.6 cm
Dr. and Mrs. Steven Richmond, Toronto

32.
Zanzibar Series: Brainstorming, 1981
Coloured inks and acrylic on paper
66.0 x 101.2 cm
Andrew Wainwright and Marjorie Stone,
Halifax

33.
Cushioned Corner, 1984
Coloured inks and acrylic on paper
66.0 x 102.0 cm
Courtesy of The Isaacs Gallery, Toronto

34.
Untitled (after Matisse), c. 1985
Pastel, coloured inks and acrylic on paper
58.6 x 88.9 cm
Art Gallery of Ontario, gift of Marlene
Markle, Holstein, Ontario, 2001
2001/444

35.
Creation (whirligig), 1988
Acrylic, wood
123.0 x 94.0 x 157.0 cm
Thunder Bay Art Gallery Collection, private
donation

36.
River (whirligig), 1988
Acrylic, wood
80.5 x 49.5 x 146.0 cm
Marlene Markle, Holstein, Ontario

37.
Time for the Floor, 1988
Acrylic on paper
111.8 x 75.9 cm
Art Gallery of Ontario, gift of Marlene
Markle, Holstein, Ontario, 2001
2001/446

38.
Snakes Galore, 1988
Acrylic on paper
111.8 x 76.0 cm
Art Gallery of Ontario, gift of Marlene
Markle, Holstein, Ontario, 2001
2001/445

39.
Hanover Hustle, 1988
Acrylic and pastel on paper
Diptych, left panel: 120.2 x 149.2 cm; right
panel: 120.6 x 149.4 cm
Art Gallery of Ontario, gift of Marlene
Markle, Holstein, Ontario, 2001
2001/447

40.
Country Twang, 1989
Acrylic on tempered hardboard
91.1 x 122.1 cm
Marlene Markle, Holstein, Ontario

41.
A Likeness of Being, 1989
Acrylic on tempered hardboard
92.4 x 122.2 cm
Marlene Markle, Holstein, Ontario

42.
Table Dancer: Conversation, 1990
Acrylic and coloured inks on paper
mounted on tempered hardboard
69.8 x 99.5 cm
Marlene Markle, Holstein, Ontario

43.
Rooms: The West Wall, 1990
Acrylic on tempered hardboard
46.9 x 203.5 cm
Marlene Markle, Holstein, Ontario

44.
Untitled (mater dolorosa), 1990
Acrylic, coloured inks and pastel on canvas
51.8 x 61.6 cm
Marlene Markle, Holstein, Ontario

45.
Untitled (Table Dancer), 1990
Acrylic and coloured inks on canvas
132.4 x 186.0 cm
Art Gallery of Ontario, gift of Marlene
Markle, Holstein, Ontario, 2001
2001/448

46.
Red Man Chewing Tobacco cap
20.3 cm diameter
Robert Markle fonds, series 17, box 28
E.P. Taylor Research Library and Archives,
Art Gallery of Onartio

Joyce Wieland (1930–1998)

47.
Self-Portrait, c. 1949
Oil on canvas board
61.0 x 50.9 cm
Michael Wieland, Orangeville, Ontario

48.
Untitled (kitchen conversation), 1954
Ink on paper
21.5 x 28.0 cm
Art Gallery of Ontario, gift of Betty
Ramsaur Ferguson, Puslinch, Ontario,
1998
98/632

49.
Play Jelly Rolly Again, 1954–55
Ink on paper
19.2 x 25.8 cm
Paul and Margaret Break, Toronto

50.
Untitled (couple), between 1954 and 1956
Ink on paper
27.9 x 43.4 cm
Art Gallery of Ontario, gift of Betty
Ramsaur Ferguson, Puslinch, Ontario,
1998
98/634

51.
Untitled (lovers with dove),
between 1954 and 1958
Ink on paper
21.5 x 28.0 cm
Art Gallery of Ontario, gift of Betty
Ramsaur Ferguson, Puslinch, Ontario,
1998
98/608

52.
Untitled (lovers joined),
between 1954 and 1958
Ink on paper
21.5 x 28.0 cm
Art Gallery of Ontario, gift of Betty
Ramsaur Ferguson, Puslinch, Ontario,
1998
98/639

53.
Untitled (in the kitchen),
between 1954 and 1958
Ink on paper
25.8 x 28.0 cm
Art Gallery of Ontario, gift of Betty
Ramsaur Ferguson, Puslinch, Ontario,
1998
98/621

54.
*Lady Examining her Magic and Protective
Circle*, c. 1955
Black crayon on paper
27.9 x 44.3 cm
Art Gallery of Ontario, gift from the Estate
of Donald F. Vincent, London, Ontario,
2000
2000/31

55.
Woman amusing herself, c. 1955
Black crayon on paper
27.9 x 43.4 cm
Art Gallery of Ontario, gift of Betty
Ramsaur Ferguson, Puslinch, Ontario,
1998
98/633

56.
Untitled (play), 1956
Ink on paper
13.6 x 20.7 cm
Art Gallery of Ontario, gift of Betty
Ramsaur Ferguson, Puslinch, Ontario,
1998
98/599

57.
Lovers, 1956
Ink on paper
21.5 x 28.0 cm
Art Gallery of Ontario, gift of Betty
Ramsaur Ferguson, Puslinch, Ontario,
1998
98/604

58.
Untitled (couple), 1956
Ink on paper
13.7 x 21.0 cm
Art Gallery of Ontario, gift of Betty
Ramsaur Ferguson, Puslinch, Ontario,
1998
98/626

59.
Chain, 1956
Ink on paper
13.7 x 20.8 cm
Art Gallery of Ontario, gift of Betty
Ramsaur Ferguson, Puslinch, Ontario,
1998
98/627

60.
Untitled (lovers), 1956
Ink on paper
20.7 x 13.6 cm
Art Gallery of Ontario, gift of Betty
Ramsaur Ferguson, Puslinch, Ontario,
1998
98/590

61.
Lovers (ii), 1956
Ink on paper
13.5 x 21.0 cm
Art Gallery of Ontario, gift of Betty
Ramsaur Ferguson, Puslinch, Ontario,
1998
98/611

62.
Lovers (iii), 1956
Ink on paper
20.7 x 13.6 cm
Art Gallery of Ontario, gift of Betty
Ramsaur Ferguson, Puslinch, Ontario,
1998
98/612

63.
Lovers, 1956
Ink on paper
13.7 x 21.1 cm
Art Gallery of Ontario, gift of Betty
Ramsaur Ferguson, Puslinch, Ontario,
1998
98/625

64.
Lovers, 1956
Ink on paper
21.5 x 27.9 cm
Art Gallery of Ontario, gift of Betty
Ramsaur Ferguson, Puslinch, Ontario,
1998
98/640

65.
Picture Upset by the Moon,
between 1956 and 1958
Ink on paper
13.6 x 20.4 cm
Art Gallery of Ontario, gift of Betty
Ramsaur Ferguson, Puslinch, Ontario,
1998
98/628

66.
Untitled (arching figure),
between 1956 and 1960
Ink on paper
13.9 x 20.4 cm
Art Gallery of Ontario, gift of Betty
Ramsaur Ferguson, Puslinch, Ontario,
1998
98/601

67.
Self-Portrait, 1957
Ink on paper
24.0 x 29.2 cm
Brenda Hebert and Brent Lisowski,
Toronto

68.
Myself, 1958
Oil on canvas
56.0 x 71.9 cm
Paul and Margaret Break, Toronto

69.
Woman is a parasite, c. 1958
Ink on paper
27.9 x 43.4 cm
Art Gallery of Ontario, gift of Betty
Ramsaur Ferguson, Puslinch, Ontario,
1998
98/635

70.
Lovers with Curly Hair, c. 1958
Ink on paper
27.9 x 43.4 cm
Art Gallery of Ontario, gift of Betty
Ramsaur Ferguson, Puslinch, Ontario,
1998
98/637

71.
Untitled (love explosion),
between 1960 and 1962
Black pencil and white chalk on paper
21.3 x 27.8 cm
Art Gallery of Ontario, gift of Betty
Ramsaur Ferguson, Puslinch, Ontario,
1998
98/643

72.
Lovers, c. 1960
Black pencil and white chalk on paper
22.8 x 15.2 cm
Art Gallery of Ontario, gift of Betty
Ramsaur Ferguson, Puslinch, Ontario,
1998
98/620

73.
Untitled (lovers jumping), c. 1960
Black pencil and white chalk on paper
22.8 x 15.2 cm
Gift of Betty Ramsaur Ferguson, Puslinch,
Ontario, 1998
98/617

74.
The Kiss, 1960
Oil on canvas
81.4 x 63.5 cm
Vancouver Art Gallery; gift of Donna
Montague

75.
Redgasm, 1960
Oil on canvas
71.5 x 117.0 cm
Mr. and Mrs. Herzig, Toronto

76.
Spring Blues, 1960
Collage: oil paint, paper and mirror
fragments on canvas
117.5 x 82.1 cm
Douglas MacPherson, Toronto

77.
Clothes of Love, 1960–61
Mixed media assemblage
151.5 x 76.0 cm
Rachel Barney, Toronto

78.
Time Machine Series, 1961
Oil on canvas
203.2 x 269.9 cm
Art Gallery of Ontario, gift from the
McLean Foundation, 1966
65/25

79.
Untitled (love scratches), c. 1961
Black pencil and white chalk on paper
27.9 x 41.7 cm
Art Gallery of Ontario, gift of Betty
Ramsaur Ferguson, Puslinch, Ontario,
1998
98/638

80.
Untitled ("C"), c. 1961
Black pencil and white chalk on paper
21.3 x 27.8 cm
Art Gallery of Ontario, gift of Betty
Ramsaur Ferguson, Puslinch, Ontario,
1998
98/644

81.
Penis Wallpaper, 1962
Oil on canvas
20.1 x 23.1 cm
Mr. and Mrs. L. Lawrence, Toronto

82.
Joyce Wieland and Betty Ferguson
Barbara's Blindness, 1965
17 minutes, colour, sound, 16mm film
Betty Ferguson, Puslinch, Ontario

83.
Handtinting, 1967–68
5.5 minutes, colour, silent, 16mm film
Art Gallery of Ontario

84.
*The Spirit of Canada Suckles the French
and English Beavers,* 1970–71
Bronze
6.0 x 9.3 x 19.3 cm
Jean Sutherland Boggs, Westmount,
Quebec

85.
Bear and Spirit of Canada, 1970–71
Bronze
7.5 x 13.3 x 20.0 cm
Munro Ferguson, Montreal

86.
Le Castor doux, Parfum par Joyce Wieland
(The Perfume of Canadian Liberation), 1971
bottle: 5.4 x 2.5 x 2.6 cm;
box: 7.1 x 5.5 x 5.5 cm
Douglas MacPherson, Toronto

87.
Facing North-Self Impression, 1973
Lithograph on paper
33.1 x 43.6 cm
Art Gallery of Ontario, purchase, 1987
86/286

88.
Self-Portrait, 1978
Oil on canvas
20.6 x 20.3 cm
Agnes Etherington Art Centre, Queen's
University, Kingston, Purchase, Chancellor
Richardson Memorial Fund, 1993

89.
Death from Drowning, 1979
Coloured pencil on paper
21.9 x 21.6 cm
Paul and Joyce Chapnick, Toronto

90.
Morning Vision, 1979
Coloured pencil on paper
27.9 x 31.8 cm
Paul and Joyce Chapnick, Toronto

91.
Bloom of Matter: Spring, 1980
Coloured pencil on paper
27.3 x 38.0 cm
Purchase, 1981
80/192

92.
Untitled (bather and lamb),
between 1980 and 1982
Coloured pencil on paper
28.0 x 35.5 cm
Art Gallery of Ontario, gift of Betty
Ramsaur Ferguson, Puslinch, Ontario,
1998
98/606

93.
Untitled (bather and hare),
between 1980 and 1982
Graphite and coloured pencil on paper
29.5 x 38.8 cm
Art Gallery of Ontario, gift of Betty
Ramsaur Ferguson, Puslinch, Ontario, 1998
98/642

94.
The one above waits for those below, 1981
Coloured pencil on paper
39.4 x 50.8 cm
From the collection of the Canada Council
Art Bank

95.
Victory of Venus, 1981
Coloured pencil on paper
48.4 x 61.0 cm
Art Gallery of Ontario, purchased with
funds donated by AGO Members, 2002
2002/47

96.
Untitled (murderous angel),
between 1981 and 1984
Acrylic on canvas
112.0 x 172.6 cm
Sara Bowser Barney, Toronto

97.
Untitled, 1982
Ink on paper
28.0 x 35.5 cm
Su Rynard, Toronto

98.
Artemis, 1983
10 colour photocopies, each 21.6 x 27.9 cm
Michael Wieland, Orangeville, Ontario

99.
Artist on Fire, 1983
Oil on canvas
107.2 x 130.0 cm
Robert McLaughlin Gallery, Oshawa,
purchase, 1984

100.
Paint Phantom, 1983–84
Oil on canvas
121.9 x 170.2 cm
National Gallery of Canada, Ottawa,
purchased 1985

101.
Untitled (Goddess), 1984–86
Acrylic on canvas
239.0 x 249.1 cm
Su Rynard, Toronto

102.
Mozart and Wieland, 1985
Oil on canvas
137.2 x 129.6 cm
Private collection, Ottawa

103.
Untitled (Goddess),
between 1988 and 1990
Graphite on paper
24.3 x 34.4 cm
Betty Ferguson, Puslinch, Ontario

104.
Menstrual Dance, 1987
Oil on canvas
86.6 x 117.1 cm
Betty Ferguson, Puslinch, Ontario

105.
Taxidermic beaver from the collection of
Joyce Wieland
23.0 x 21.0 x 83.0 cm
Rachel Barney, Toronto